IMAGES
of America

BROWNS VALLEY

Roberta Sperbeck D'Arcy

ARCADIA
PUBLISHING

Published by Arcadia Publishing
Charleston, South Carolina

Printed in the United States of America

Library of Congress Control Number: 2011930736

For all general information, please contact Arcadia Publishing:
Telephone 843-853-2070
Fax 843-853-0044
E-mail sales@arcadiapublishing.com
For customer service and orders:
Toll-Free 1-888-313-2665

Visit us on the Internet at www.arcadiapublishing.com

This book is dedicated to all the Browns Valley residents who love this place and are still here because they would not live anywhere else

CONTENTS

ACKNOWLEDGMENTS

This account could not have been accomplished without the encouragement and support of many citizens and old-timers of Browns Valley, Loma Rica, Marysville, and Yuba City. Melba Dean, Betty Songer, Ray Hoxworth, Ray Webster, Bev and Jerry Rose, Ed Silva, David Labadie, Dick Springsteen, Morry Smith, Myrna Gee, Henry Smith, Lou Binninger, the McMillan family, Patsy Sperbeck Priest, Jean Crawford, Melba Adamson, Patty Anderson, Betty Fowler, and Art and Marcella Rice are all descendants of early families and provided so many pictures and so much information. Thank you all. Charles French, Ivadene Leach, and Donna Landerman provided ideas, pictures, suggestions, and enthusiasm—I could not have done it without you. Rosemarie Mossinger of the Forbestown Museum provided pictures, as did Julie Stark of Community Memorial Museum in Yuba City, Joan Hoss of Sutter Yuba Mental Health, and Regina Zurakowski of the Yuba County Library California Room Collection—thank you. Dale Johnson, retired from Pacific Gas and Electric, and Bob Bordsen, a longtime resident and board member of the Browns Valley Irrigation District, provided pictures and their expertise. Sally Sokolowski and the Yuba County Office of Education, the Yuba Sutter Farm Bureau, the American Indian Education Program of the Marysville Joint Unified School District, and the Browns Valley 4-H Club all devoted time and energy to finding pictures. The Dorothy Hill Collection of California State University, Chico, provided rare pictures. Thanks go to Sue Ceyner Moyer—who gave me ideas, loaned materials, and offered help—and to Vicki Contente, who came through with some much-needed last-minute research. Coleen Balent, my acquisitions editor at Arcadia Publishing, provided expertise and lots of encouragement. My thanks go to my old friend Ruth Mikklesen, who lives in one of Browns Valley's most historic homes and is always generous with pictures, materials, and even homemade jam!

Lastly, this book would have remained a fantasy without the boundless encouragement and support of my husband, Roland (who kept the household running), and our children—Noelle, Brett, and Trisann—and their families, who all had faith that I could do it.

INTRODUCTION

Browns Valley lies in the Sierra Nevada foothills at the point where the broad Central Valley begins to rise to meet the mountains. Bounded on the west by the Browns Valley Ridge and to the north by Paine's Peak and Stanfield Hill (both named for early settlers to the region), it spreads around Bald Mountain to the east and reaches to the Yuba River to the south.

Before settlers and explorers from the East started arriving in this part of California in the 1830s and 1840s, small bands of Indians dotted the vast area, moving seasonally as food sources and weather changed. Groups numbered up to 200, and everyone depended on the land for sustenance and livelihood. Abundant white, black, and live oaks provided acorns, the staple food, which could be ground into a meal by hand and then cooked or dried for future use. Wild berries, grapes, plums, and grasshoppers added variety and nutrients. Small animals—such as fox, badger, squirrel, and possum—were cooked in pits made of hot rocks. Black-tailed deer were plentiful, not only providing fresh and dried meat but also hides for clothing and bedding and sinew and bone for decoration and bow construction. Knowing how to live in concert with the land kept the food supply constant and the Indians' existence assured. By 1850, when a Mr. Brown sliced into a quartz ledge while haying with his newly purchased scythe, exposing a gold vein four feet high, the Indians' well-being was already in peril, and this discovery sealed their fate.

All of a sudden, people were flooding into the area from the East and South, as well as France, Germany, and Mexico. Within a few months, hotels, boardinghouses, churches, and saloons had sprung up to support the efforts of the miners. Because the quartz was rich with gold and easily accessible at this time, the area was called Little Washoe, after the rich Nevada strike of the same name. Mr. Brown abandoned his hay cutting, began surface mining his discovery, and within weeks had taken out $12,000 worth of gold dust and moved on into history, leaving only his surname behind.

Not only did this influx of people begin logging oaks in massive numbers to build and fuel the mines and buildings being erected, they dammed creeks and commenced mining operations along streams and rivers. Tailings from these mines altered the flow of water and created piles of rock and debris all through the hills. Game was slaughtered as an easy source of food and as sport for the hardworking miners. Disease turned out to be the most detrimental effect the settlers had on the Indians. Their immune systems had no defense against smallpox, cholera, or even influenza, which took their lives in staggering numbers over a period of 30 years.

Miners and townspeople viewed their native neighbors in varying ways. Some people tried to convert them to Christianity, or civilize them, while others saw them as a source of slave labor. Often, transplants from major cities saw them as a fearful enemy to be vanquished in any way possible. References like "savages" or "red menace" abound in writings of the times. The 1850s was the heyday of gold mining in Browns Valley, with nine mines in operation at one time. During this period, mines were also active up the road in Brownsville, Oregon House, and Dobbins, as well as along the Yuba River stretching to Nevada County. To extract the gold at Long Bar, Parks Bar, and Ousley's Bar, among others along the river, hydraulic gold mining was primarily utilized. This method was devastating to the countryside, though it was an efficient way to extract gold.

Mining activities evolved from placer mining to stamp mills, which crushed or stamped the rock under high pressure and then separated gold from quartz. Mining turned out to be extremely difficult work, with average wages running about $3 to $5 per day, with the threat of debilitating accidents always present. Years of working under dangerous, stressful conditions took a huge toll on miners' health. Men were past their prime by their late 40s. As the mines wound down in production and the cost of operating them became too high, families had to find other ways to make a living. Stage stops and hotels were all along the route from Marysville to the mines in the mountains, sometimes as little as a mile apart. They provided rest and refreshments to passengers and horses and were a lucrative livelihood for the proprietors. Seven Mile House, Empire House, Galena House, and Mountain House were a few of the original buildings that endured into the 1930s. The valley proved to be temperate in weather, with fertile soil. With the formation of the Browns Valley Irrigation District in 1880, water was bountiful. These conditions proved ideal for growing grapes, figs, peaches, and olives. Cattle and sheep ranching were an important part of the local economy, and most ranchers planted and harvested their own alfalfa for hay. The work—whether it was ranching, working on the dredger, logging lumber out of the hills, running a dairy, or trying to eke a living out of the old mines—was grueling and unremitting. Illnesses, such as pneumonia or sepsis from a wound, could kill an adult in the prime of life, and local cemeteries are filled with children who died from diphtheria, scarlet fever, or measles. Despite these harsh realities, families got together to have fun whenever they had the chance. Picnics, dances, school activities, hunting, fishing, and baseball games were when people enjoyed each other's company and put work aside.

Browns Valley is a testament to all those Native Americans, early settlers, and diverse populations who passed through here and left a legacy. Townspeople, who today reflect on the rich history of the region, wonder if the current price of gold will spur a resurgence of gold fever. As one old-timer said years ago, "Miners only scratched the surface of what is up in those hills."

One

IN THE BEGINNING

The Concow-Maidu ("on our side"), or Nisenan ("from among us"), people lived in the valleys of the Yuba, Bear, and Sacramento Rivers and along the streams in the foothills of the Sierra Nevada. Before the arrival of gold-seekers, their territory stretched from north of Chico to south of Sacramento and east to Lake Tahoe. They participated in the Kuksu religion of the Sacramento Valley. This philosophy believed in rituals to restore harmony with ghosts, ensure fertility, and care for the sick. Different Maidu groups honored their dead in different ways. Some buried their dead with the deceased's personal belongings, while others burned the bodies and their personal effects. (Courtesy of Dorothy Hill Collection, California State University, Chico.)

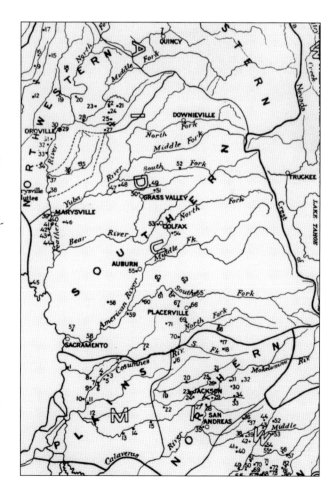

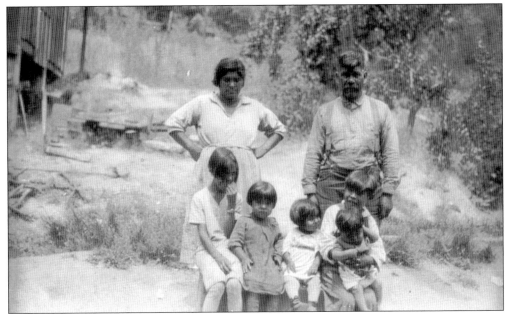

Members of this Maidu family, pictured here in the 1930s, are descendants of the ancient northwest Maidu who migrated to Butte County about 1200 BC. In 1846, their territory was home to an estimated 10,000 people, but by 1910, that number had been reduced to 1,100. (Courtesy of Dorothy Hill Collection, California State University, Chico.)

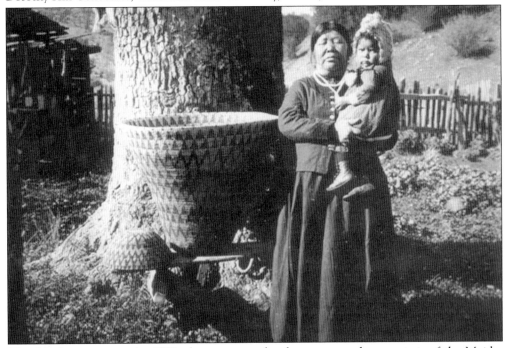

This Maidu woman in the 1920s demonstrates the short stature characteristic of the Maidu. Women wore scant clothing consisting of front and back aprons made of shredded bark. Their hair was trimmed with a hot coal, and combs of pinecones or porcupine tails were used. (Courtesy of Dorothy Hill Collection, California State University, Chico.)

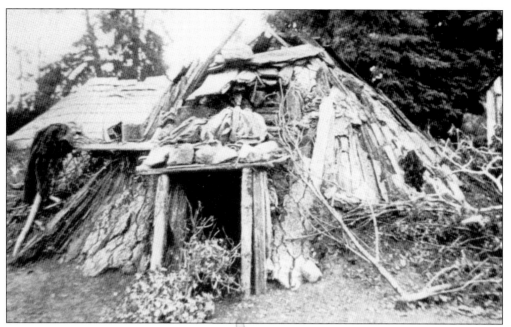

Maidu lived in huts constructed of willow poles that were stuck in the ground in a circle, bent, and secured together at the top, with an opening as a smoke vent. Sometimes, brush and leaves were interlaced through the poles for privacy and protection from the weather, and often bark was the only material used. (Courtesy of Dorothy Hill Collection, California State University, Chico.)

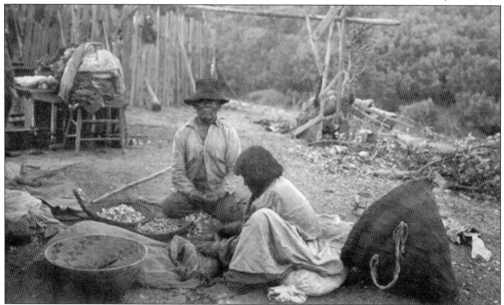

All large and small animals were utilized for food, except dogs, wolves, and coyotes, which the Maidu believed to be poisonous. When protein sources were scarce, they depended on grasshoppers. Women stood in circles in the dry grass, holding baskets and slowly moved toward each other, trapping grasshoppers in the baskets. They then dried them and used them all year. Salmon was the most easily obtainable fish from the valley, rivers, and streams. (Courtesy of Dorothy Hill Collection, California State University, Chico.)

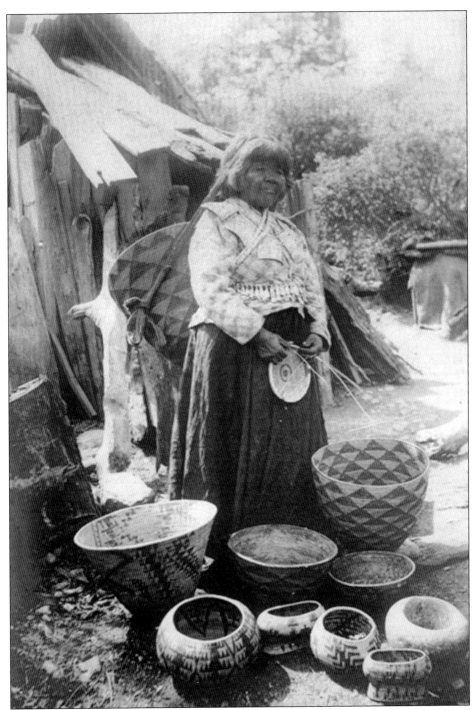

Basketry was a special skill for which the Maidu were known. They were adept at beading and feather work, and women made baskets from tule, milkweed, and wild grapevines. They used baskets for all daily activities, such as carrying water, storing acorns, catching grasshoppers, and trade with others. Intricately patterned baskets were also woven to be buried with the dead. (Courtesy of Dorothy Hill Collection, California State University, Chico.)

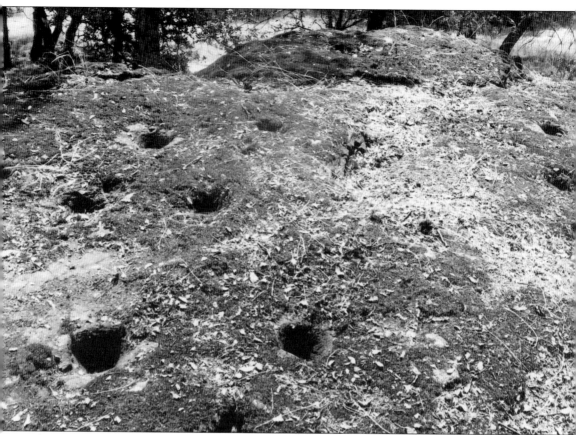

This grinding rock is in Browns Valley. These rocks are scattered all through the foothills, usually near streams. They range from having 1 depression to 20 or more, depending on the size of the rock. Acorns were gathered in the fall and stored in huge burden baskets. The acorns were protected from rain and ground into meal as needed throughout the year. Acorn meal was a staple, and it was either cooked as bread or used with other food. Since the Maidu migrated seasonally, they returned to these rocks in the fall, year after year. Pestles, baskets, bowls, and other tools were taken with them as they moved or broken and buried with them. When a woman died, her rock excavations were abandoned, never to be used by any other women. (Author's.)

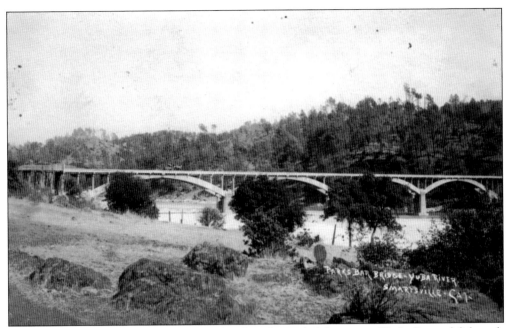

The Parks Bar Bridge was named for David Parks, who settled the town of Parks Bar and did much trading with the Indians. He said that, at first, Indians had no concept of the value of gold to the settlers and would trade a cup of gold dust for a cup of sugar. In the early years, they worked for low wages but quickly learned what was valuable and worked independently along the streams and rivers with other miners. (Courtesy of Yuba County Library Local History Archives.)

Much of the acrimony between miners, Indians, and ranchers stemmed from competition and jealousy regarding ownership of gold sites and where everyone was allowed to mine. These altercations became more and more bitter, resulting in the forced removal of Indians to a reservation in Mendocino County in 1863. In two weeks, 479 Maidu were forced to walk to Round Valley; 220 died en route. As a child, Henry Thompson was kidnapped by people passing through and raised in the Mendocino area, but he returned to Browns Valley as a young man. (Courtesy of Bancroft Library, University of California, Berkley/Leigha Robbins.)

Before Mr. Brown's scythe struck gold in Browns Valley, there was mining activity along the Feather, Yuba, and Sacramento Rivers. In the fall of 1849, gold was found on the Yuba between what is now the Parks Bar Bridge and Hammon Grove. This became Long Bar, one of the richest strikes on the river, three miles east of Browns Valley. By the spring of 1850, a thousand people lived there and the Long Bar Post Office was established. (Courtesy of Yuba County Library Local History Archives.)

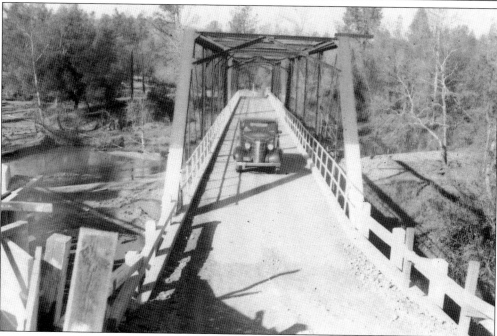

In 1856, a bridge was built across Dry Creek, which made access to Long Bar easier. Bakeries, saloons, and stores were built. The following about a July party is from a *Marysville Appeal* article in July 1864: "The glorious Fourth at the Bar was celebrated in a very appropriate and creditable manner. A free dinner was held in the best style of the art. Proceedings in the evening were characterized by a brilliant display of fireworks from the hill in front of Cartwright's." This Dry Creek bridge was built 80 years later. (Courtesy of Yuba County Library Local History Archives.)

Ousley's Bar, another early mining site along the Yuba, was settled in 1849 by Dr. Ousley, who had first practiced medicine in the mining camps until he saw it would be much more lucrative to find gold. Dr. Red, as he was known, developed his claim at the confluence of Dry Creek and the Yuba River, at what is now Sycamore Ranch. Ousley's Bar grew to 1,000 people, with a post office opening in 1855. Gold was getting scarce by 1858, so Dr. Red abandoned his claim, and in 1865, the post office closed. This view is across Dry Creek, facing south to the Yuba River. The massive gravel hills in the background are tailings excavated by dredgers. (Author's.)

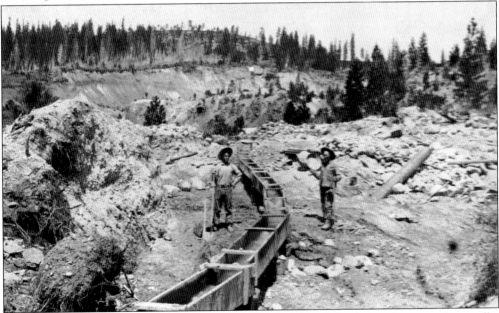

When Mr. Brown mined out the first $12,000 worth of gold, he did so by hand, using only a cradle, sluice box, or Long Tom (a long, thin box made of metal or wood and upon which several men could work simultaneously) to extract the gold from gravel and larger rocks. Even panning for gold was an option for men who had little money for supplies. Gold panning required a flat pan for use at the edge of a stream or with any steady supply of water and a lot of patience. (Courtesy of Yuba County Library Local History Archives.)

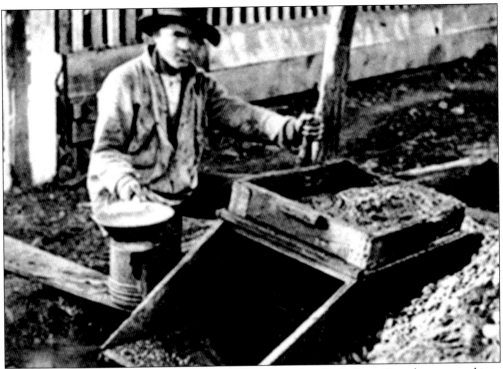

This is an example of a sluice box being worked by an unidentified miner. Gravel was poured into the sluice box, and water, which could be regulated by the valve at one end, washed the ore. Then, gold fell to the bottom of the box and was retrieved. This method produced results because gold is the densest metal known to man. (Courtesy of Yuba County Library Local History Archives.)

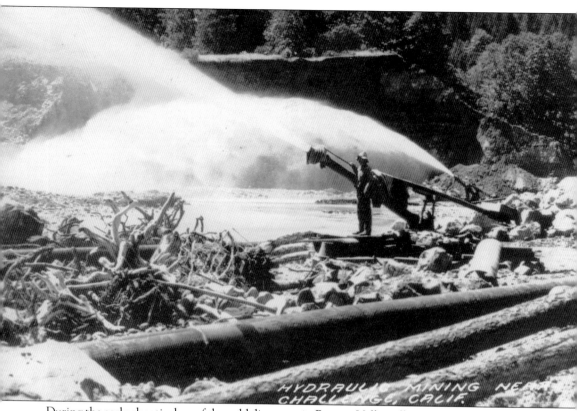

During the early chaotic days of the gold discovery in Browns Valley, all manner of gold extraction was used, many times simultaneously. Hydraulic mining, pictured here, used high-power hoses fitted on massive cannon-like devices called monitors. Monitors could be as long as 16 feet, with 5,000 pounds of water pressure exploding from the nozzles. Wooden frames held the hoses and monitors. This method of gold extraction shot rocks and chunks of hillside down through huge iron pipes to sluice boxes below, where gold dropped to the bottom and was retrieved. If a hillside remained impervious to all the water and pick-and-shovel pressure exerted upon it, dynamite was used to break up rock. When up to 300 kegs were placed deep in a tunnel, packed with dirt, and then lit, a dull roar was heard, and the whole mountain rose up and settled down. A brand-new area was created to be flushed down the hillside. (Courtesy of Charles French.)

Two

MINING IS KING

By 1853, disputes over mining claims were frequent and sometimes life threatening. Often a knife or gun battle would end in serious injury or death. Miners initiated a loose coalition, which met semiannually, where the claim owner or proxy had to be present and arguments resolved or the claim would be forfeited. Claims were 60 feet long and had to be marked off by stakes in the ground. Competition for paying claims was so fierce that someone had to be present and working the claim continuously or it would be hijacked from the owner. These miners are working in eastern Yuba County. (Courtesy of Charles French.)

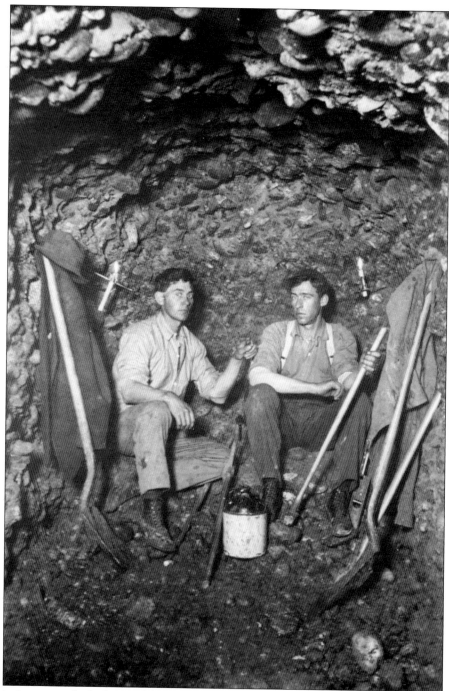

By this time, men who had arrived from all over the globe to make their fortune were facing horrific challenges they had not expected and for which they were not prepared. Cholera, dysentery, and influenza ravaged the mining camps. Many lived on the edge of starvation for months at a time, waiting for their big strike. Isolation and loneliness drove up the suicide rate. Here, Mr. King (left) and Mr. Reed are lucky to be healthy and apparently content as they pause in their work at the Pennsylvania Mine. (Courtesy of Ivadene Leach.)

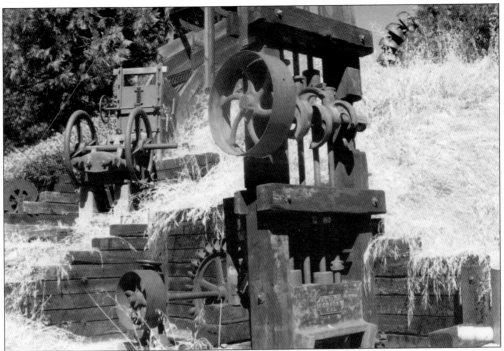

Over time, men used to panning or sluicing realized gold for the taking was gone and that the quartz must be smashed to extract the gold. As oysters hold pearls, so quartz, a white and sometimes transparent rock, held gold locked inside. Stamp mills were the first mass-produced machines used to crush and grind quartz. Stamps were rock weights dropped on the ore by a crankshaft. The crushed ore was then further refined with a mercury or cyanide process. (Author's.)

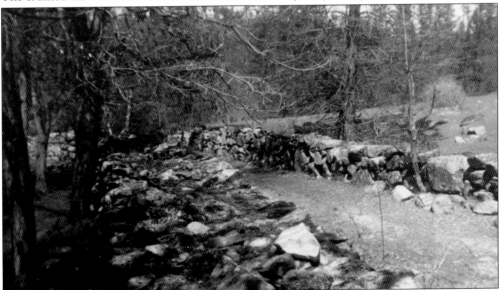

Rock walls that meander through several areas in the Browns Valley foothills were constructed by Chinese and Irish immigrants who had come to work in the mines. If mines needed more investors or the machinery had broken down, men had to find work wherever they could. (Courtesy of Charles French.)

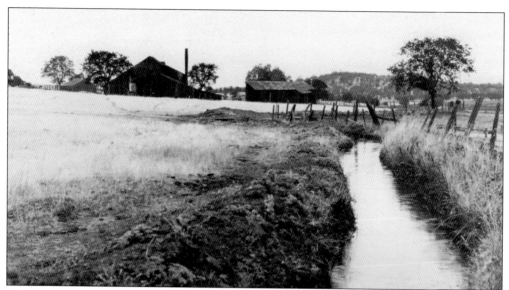

The first mine to employ a stamp mill in California was the Sweet Vengeance Mine on Back Road (now called Spring Valley Road). This mine, first owned by Spaniards and then acquired by Frenchmen, had five, 850-pound stamps, which pulverized ore under pressure. The Jefferson Mine, just south of Browns Valley, utilized a 12-stamp mill that was operated by steam power. (Courtesy of Betty Kunde.)

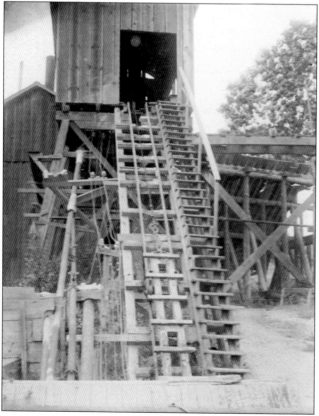

In 1867, the Pennsylvania Mine (whose head frame is seen here), located between the Jefferson Mine and the post office, went down 600 feet and had a 16-stamp mill. Originally named the Plymouth, the Dannebroge Mine at the base of Browns Valley Ridge sank a shaft 500 feet and had drifts of 200 feet. A single head in a stamp mill could crush one and a half tons of ore. Drifts were horizontal tunnels that opened off the main line and followed rich veins until they ran out. Sometimes drifts intersected with others in the same mine or even a different mine. (Courtesy of Ivadene Leach.)

A hoist at the Pennsylvania Mine is run by cables on a track powered by a massive engine. It allowed men to travel down the shaft to the mining depths in an ore cart and then pulled the cart back up full of ore to be milled. This engine room illustrates the breadth and complexity of the machinery. (Courtesy of Ivadene Leach.)

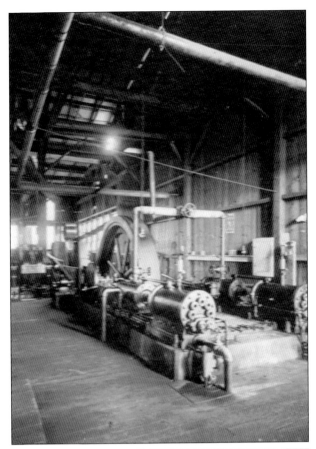

Fire, the nemesis of the mining camps with wooden buildings that had been hastily thrown up, struck Browns Valley in 1867, starting in Jake Knorsa's store and spreading to the whole business section. Saloons, bakeries, hotels, and several stores went up in flames. The Central Hotel, pictured here, was one of the few buildings that survived into the 1930s. With the focus of most residents centered on mining, fewer buildings were rebuilt each time fire struck. (Courtesy of Yuba County Library Local History Archives.)

A more recent fire swept through the foothills in 1935. Staggering losses are detailed in this clipping from the *Appeal Democrat*. (Author's.)

The Sweet Vengeance Mine owners transported their crushed ore to an *arrestre* two miles away on Little Dry Creek. An example of an *arrestre* is depicted here. The ore was ground to dust by mules tethered to a frame and pulling giant rocks in a circle over the ore to further break it down. This method was taught to the prospectors by Mexican miners. (Courtesy of *The Miners Own Book: California Mining*.)

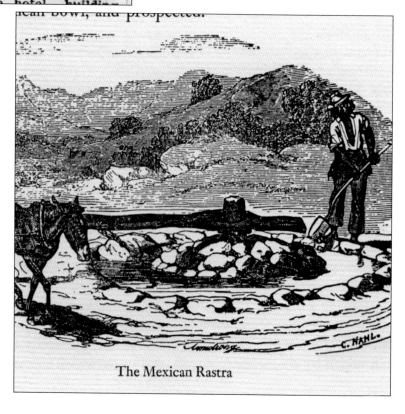

The Mexican Rastra

24

African Americans arrived to work in the mines in Browns Valley from the South and East. Jobs held around the mines were usually menial, but gradually, as black men learned the intricacies of the mining profession, many became successful. Edward Duplex, whose grave is shown here at the old Marysville Cemetery, arrived from Connecticut in 1855. He and other black miners operated the Sweet Vengeance Mine, took out a profit, and even successfully defended themselves against white miners who tried to take it over by force. By 1858, he had opened a large barbershop in Marysville and, in 1868, was listed as secretary-treasurer and on the board of directors of the Rare, Ripe Gold and Silver Mining Company in Browns Valley. In 1875, he moved to Wheatland and became the first black mayor west of the Mississippi. (Author's.)

By 1911, the Sweet Vengeance Mine was idle—reportedly caved in with water filling the lower levels. Students at Spring Valley School in the 1920s and 1930s would walk to the adjoining field and climb on the tailings of the old mine. Charles French (wearing suspenders) is on the far left of the front row, and Betty Pickett (curly hair) is in the center of the back row. (Courtesy of Betty Kunde.)

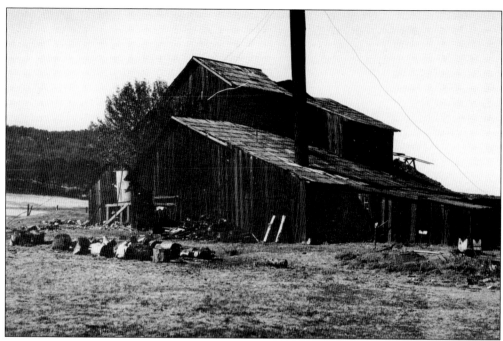

Other mines along Spring Valley Road included the Rattlesnake, the Flag, the Bessie, and the Smethurst. Pictured here is the stamp mill of the Rattlesnake. (Courtesy of Betty Kunde.)

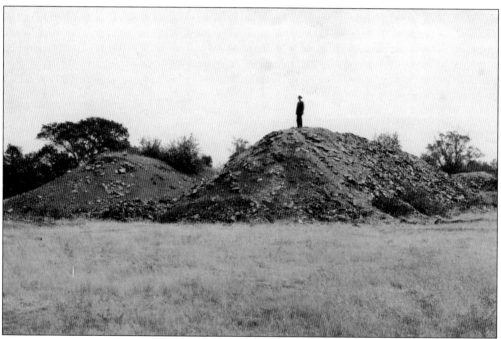

Here are tailings from the Rattlesnake Mine. Often, Chinese miners worked the tailings with sluice boxes or Long Toms after the original miners were finished with the ore and took out sizeable amounts of gold. (Courtesy of Betty Kunde.)

The arrow points to the stamp mill of the Smethurst Mine. This mine, operated by George Smethurst, a former Pony Express rider in the 1900s, was one of the longest operating mines on Spring Valley Road. (Courtesy of Betty Kunde.)

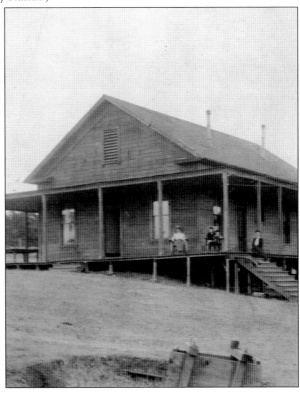

This is the office for Dannebroge Mine. Not only did the mines require miners to do the work but they also required many other people to keep the operation going. Steam mills needed men to cut and haul wood and keep the fires going. Oaks were harvested in such large amounts that whole hillsides were cleared. One mine being sold at auction detailed not only the machinery for sale but also 22 cords of wood as an asset. They needed men to work aboveground hauling ore to the tailings, administrative people to keep books, men to keep the machinery in working order, and, always, more investors to fund it all. (Courtesy of Ivadene Leach.)

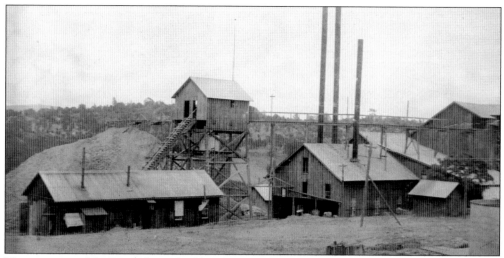

This is a view of the Dannebroge buildings from the office porch around 1900, facing east across the valley. At the height of production, this mine had eight stamps to crush rock. (Courtesy of Ivadene Leach.)

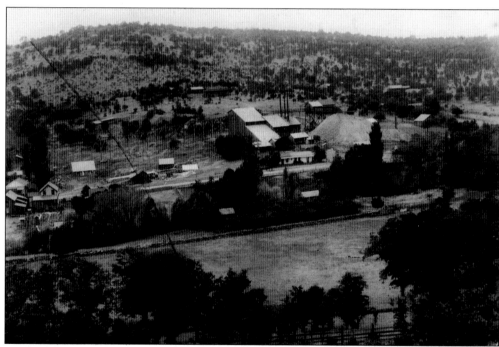

Note the flume running from the Dannebroge Mine over to the Pennsylvania Mine. Wooden flumes were a last resort when a sufficient head of water could not be attained by height or distance. The wood had to be replaced every 6 to 10 years. Besides carrying water to where it could be used in milling, flumes were also used when miners were working by hand to divert water away so that a stretch of stream or river could be worked more easily. (Courtesy of Yuba County Library Local History Archives.)

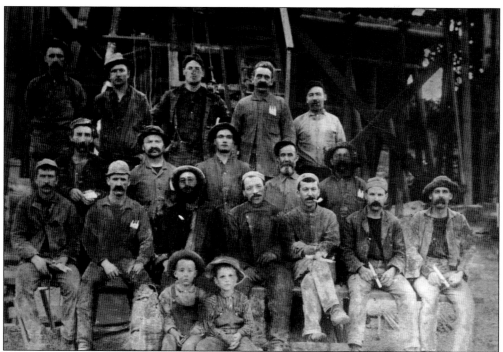

The miners of the Pennsylvania Mine pose for a picture in 1902. Some men are holding the candles that they use for light in the mine. Jacob Sperbeck, age 26, is on the far left in the second row of adults. The two children were also probably employed as helpers aboveground, as families often relied on children to contribute income. By 1904, the National Child Labor Committee formed, and child-labor law reform began. (Author's.)

If supplies for the mines could not be obtained locally, they had to be brought up the river to Marysville, unloaded, and then loaded on wagons with pack mules for the long trek into the foothills and mountains. Between 1850 and 1852, it was estimated that 4,000 mules and 400 wagons were engaged in moving supplies into the hills. (Courtesy of the Scott family.)

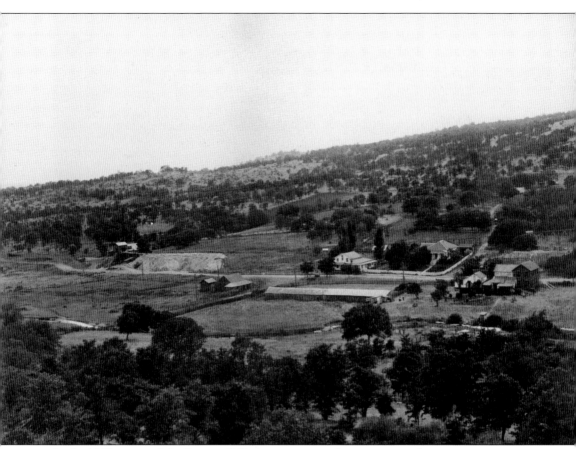

In the 1860s, many of the Browns Valley mines were making money, and new mines were opening as fast as investors could be found. A correspondent of the *Marysville Appeal* in March 1864 describes the Jefferson Mine as showing receipts of $30,957 for the crushings in February. The first week of March brought in $10,000 from the Jefferson Mine. The Jefferson was on Browns Valley Ridge, on the left of the Pennsylvania Mine, which is shown to the far left here. (Courtesy of Ivadene Leach.)

With this amount of wealth suddenly accumulating in rural counties, it was inevitable that criminals would see easy pickings in Yuba County, and Browns Valley was the site of some of the most sophisticated and vicious robberies documented. Born in Norfolk, England, in 1829, Charles Bowles, alias "Black Bart," came to the United States as a child and grew up in New York and Illinois. He settled his wife and four children in Missouri and headed west to the gold fields. He began robbing Wells Fargo stagecoaches in 1875, allegedly after he became furious at Wells Fargo. He was known as a stylish, polite bandit. When requesting the mail sack in a stagecoach robbery, he said, "Kindly pass it out. I have other duties to perform today, and haste is essential." He simulated guns in robberies but never shot anyone. He only took the lockbox or mail sack, never robbed the passengers. His 19th robbery was four miles east of Dobbins. His second robbery was four miles south of Smartsville, very close to Browns Valley. Twice, he left poems signed "Black Bart, the PO 8" pinned to the broken lockbox at the site of his crimes. Apprehended only 18 days after his last robbery, he waived a jury trial and pleaded guilty to a single count of robbing the Sonora-Milton stage. Black Bart was sentenced to six years in San Quentin, served four years, and was released. As far as it is known, he never contacted his wife and children again. It is unknown where he lived the rest of his life, what alias he used, or where he is buried. (Courtesy of Yuba County Library Local History Archives.)

Robber's Rock in Browns Valley was allegedly where bandits hid while waiting to rob the stages. Tom Bell may have hidden here before he committed a vicious crime, the one for which he would hang. Known as the "Outlaw Doc," he had worked as a surgeon in the Mexican-American War, afterward drifting around California as a gambler and a physician. While serving a sentence for robbery on Angel Island, San Francisco, he and several others escaped and formed a gang. Reports of the size of this gang varied, with estimates of up to 30 men and women. In contrast to Black Bart, Bell and the others were known to be dangerous, not hesitating to use guns for their crimes. On August 12, 1856, they heard that the Marysville-Camptonville stage was carrying $100,000 worth of gold bullion. Ambushing the stage near Dry Creek in Browns Valley, the attempted heist went bad, and at least 40 shots were exchanged between the robbers, armed passengers, and the driver. A passenger, Mrs. Thiglman (in some accounts spelled Tilghman), a barber's wife from Marysville, was shot in the head by Bell and killed instantly. Two other men were wounded. One of the Bell gang was captured in late September, and he gave up Bell's location to the Stockton sheriff. Before the Stockton sheriff could arrest him, a vigilante posse consisting of citizens and lawmen hanged Bell. He was 31. (Author's.)

This woman, known only as Belle, reportedly belonged to an outlaw gang of stage robbers, possibly Tom Bell's. Women in these anything-goes times were not confined to just being a cook or housewife. Some became rich as prostitutes, miners, or even stage robbers. (Courtesy of Jean Crawford.)

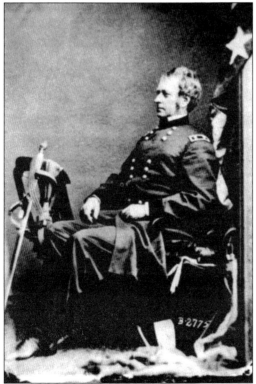

War news was at fever pitch in 1863, even though the news reached Browns Valley weeks after the fact. After California swung its support to the union side, people were afraid of retaliation by the South. Rumors of a Confederate ship and a British ship off San Francisco Bay heightened the paranoia. The Hooker Guards of Browns Valley was formed in response to these fears. Named in honor of Gen. Joseph "Fighting Joe" Hooker, pictured here, whom President Lincoln had just placed in command of the Army of the Potomac, its captain was L.D. Webb and first lieutenant was George Leland. Indian and white relations had deteriorated to the point that several of these volunteer units were used to protect the citizenry from feared attacks by Indians. (Courtesy of Vicki Contente.)

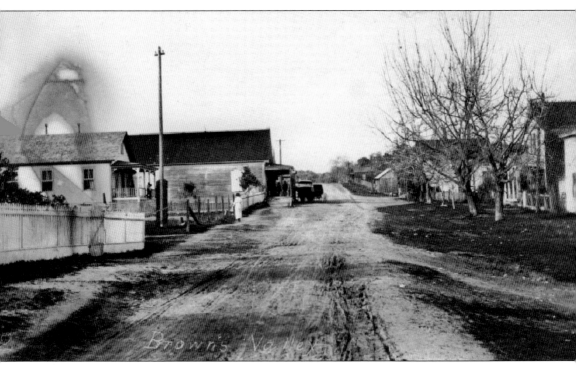

At one point during these feverish times, nine different mines were paying wages, but because of a lack of adequate water and the expense of pumping it using steam, profits were being eaten up. The need for a dependable, year-round source of water for Browns Valley was acute. Shown facing north is the main street of Browns Valley around the turn of the 20th century. (Courtesy of Ivadene Leach.)

Three

RICHES TO RANCHES

In 1879, results of 30 years of whole Sierra hillsides being flushed into streams and rivers became evident in the raised riverbeds downstream. Estimates by mining engineers revealed that 18,000 acres of rich farmlands were covered by mining debris. By the 1880s, farmers began to fight back. In 1884, US Circuit judge Lorenzo Sawyer handed down a ruling that mining debris could not be dumped where it could reach farmlands or navigable rivers. Daguerre Dam was built in 1906 to contain and control the flow and channel of the Yuba River and prevent mining debris from washing into the Feather River. A low-head dam with a 20-foot drop, it was constructed so farmers downstream could count on receiving water for crops. (Courtesy of Marie Royat.)

Paynes Peak, one of the most visible peaks surrounding Browns Valley, is 1,122 feet high at the summit, but several nearby mountains dwarf it. To the east is Stanfield Hill at 1,690 feet high, and farther south is Red Hill at 1,378 feet high. Because of its visibility and craggy rocks, Paynes Peak is an imposing mountain and was formerly home to wild hogs, mountain sheep, and the occasional California bear. It now has coyotes, rattlesnakes, and deer. It is named for John Payne, who settled here during the Gold Rush and established a stage stop and hotel at its base. (Author's.)

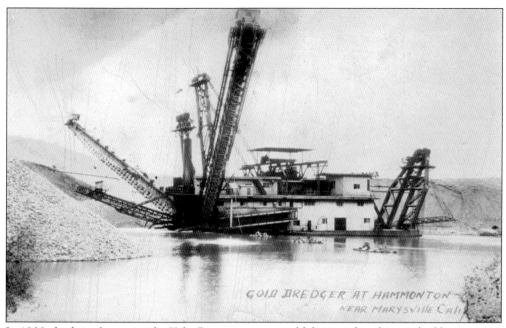

In 1900, dredging began on the Yuba River to recover gold deposited in the riverbed by upstream mining. Dredges were massive pieces of machinery up to 500 feet in length. Productivity of the Browns Valley mines had begun to wane, and residents were looking for other means of employment. (Courtesy of Arthur Rice.)

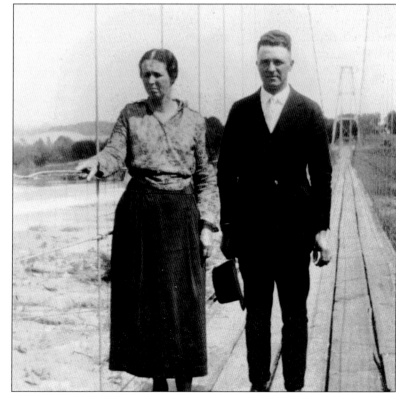

This swinging bridge spanned the Yuba River so that residents on both sides of the river did not have to drive clear into Marysville and out again to get to Hammonton and the dredger. Alice May Hedger and her son Joseph Rice are seen walking the bridge around 1913. Note the river running swiftly underneath them. The bridge was supported by a gantry at both ends. (Courtesy of Marie Royat.)

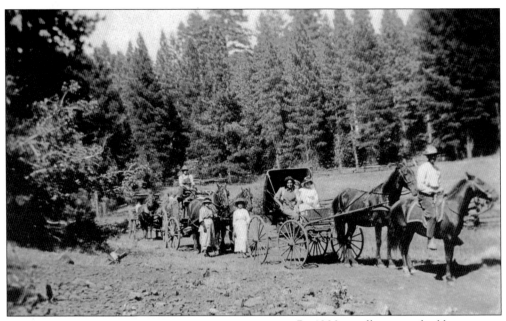

By 1900, smaller mines had been forced out of business by the increasing complexity and skyrocketing cost of mining operations. Remaining mines were the Pennsylvania, the Jefferson, the Dannebroge, and the Smethurst, which continued to take out large amounts of gold through 1905. People were still enjoying prosperity, as shown by this Sunday trip into the mountains. (Courtesy of Jean Crawford.)

One of the oldest irrigation systems in the state, Browns Valley Irrigation District was formed in September 1888 to bring a much-needed, dependable water flow to Browns Valley. A bond election raised $110,000 to build a diversion dam on the Yuba River. By August 1890, there had been 2,500 miner's inches of water delivered to Browns Valley. Dimensions of a miner's inch vary by state; in California, a miner's inch measures the release of 1/50 of a cubic foot of water per second. (Courtesy of Robert Bordsen.)

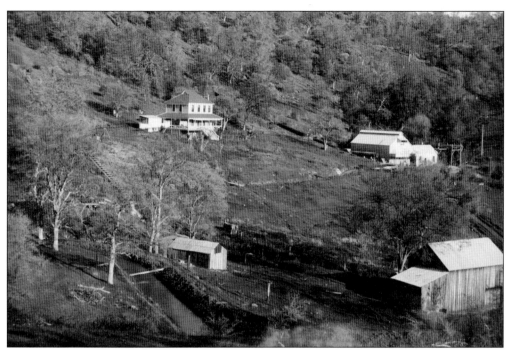

The Yuba Power Company built a pioneer hydroelectric powerhouse in 1898 at a location near Dry Creek, where there was a natural drop in the Browns Valley Irrigation District (BVID) ditch. The powerhouse is at center right. (Courtesy of Dale Johnson, Pacific Gas and Electric archives.)

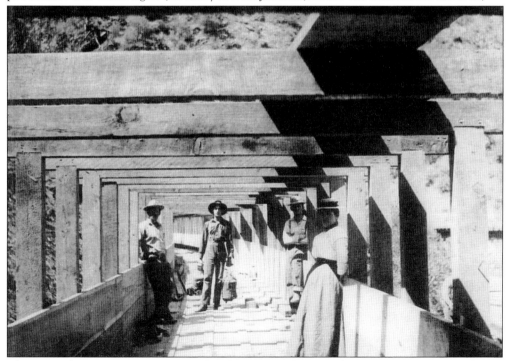

The original 1893 BVID flume was replaced in 1899 with a much larger flume, shown here during construction. (Courtesy of Dale Johnson, Pacific Gas and Electric archives.)

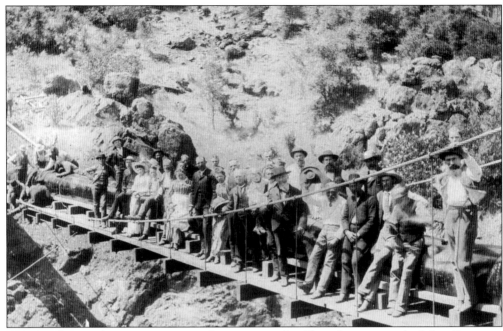

The new flume is being commemorated on opening day. Note the men on the left still putting on the finishing touch. (Courtesy of Dale Johnson, Pacific Gas and Electric archives.)

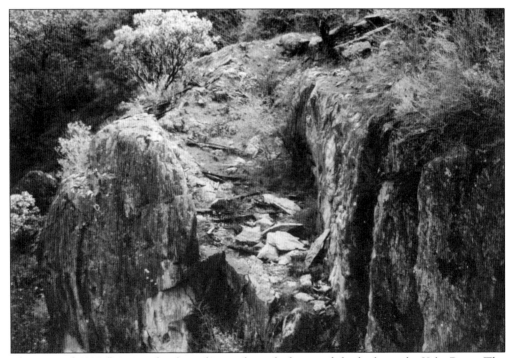

The original 1893 flume made of wood went through this notch high above the Yuba River. The notch was blasted open with dynamite. (Courtesy of Dale Johnson.)

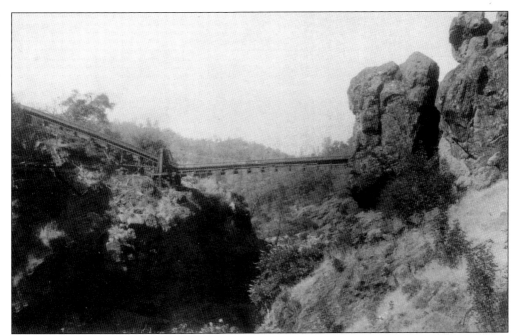

The BVID water was sent down to the powerhouse in a pressurized iron pipe called a penstock, which is a tube or trough used to carry water. (Courtesy of Dale Johnson, Pacific Gas and Electric archives.)

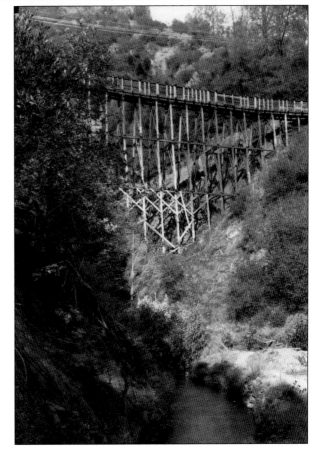

This flume was located at the point where the BVID ditch crossed over Dobbins Creek. After the water arrived via 50 miles of ditch and flume from the Yuba River, it "made it a country of green grass and blossoms, where only a few years ago was a rocky unproductive sheep range," according to William "Bull" Meek in *From Cradle to Grave*. (Courtesy of Dale Johnson, Pacific Gas and Electric archives.)

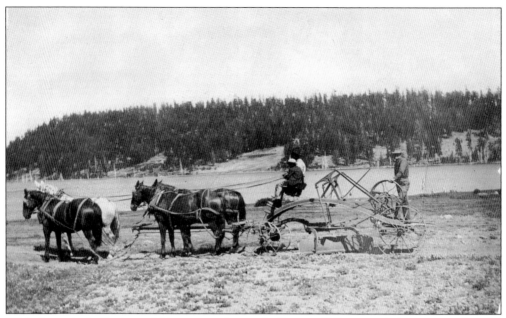

With the arrival of a dependable source of water in Browns Valley, people began to realize the possibilities of crop diversity and the adaptability of the land for ranching and small businesses, such as dairies. Here, a four-horse team on the Heintzen ranch scrapes the field for spring planting. (Courtesy of Jean Crawford.)

Charles Heintzen—born in Altenberg, Germany, in 1826—came first to New York at the age of 12. He worked for several years and came by way of the Panama Canal to San Francisco, making it to Yuba County in 1850. He began mining at Long Bar and Downieville, with much success. In 1857, he returned to the East and found his bride, Sarah Summers. Charles and Sarah traveled by stage back to California and settled in Forest City. Over the next 30 years, his multiple business interests included banking, owning and operating mercantile companies, and continuing to mine. Upon retirement in 1896, he bought 700 acres on Spring Valley Road on the west side of Browns Valley Ridge. (Courtesy of Jean Crawford.)

This is Charles and Sarah's original house on the Heintzen ranch, to which they moved with their three children, Jeannette and twins Leon and Zetta. Granddaughter Lita gives a ride to a long-suffering dog. (Courtesy of Jean Crawford.)

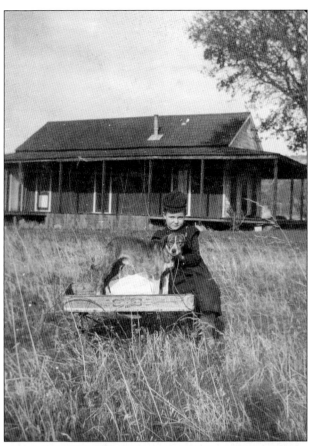

Seen here, holding baby Lita, Leon Heintzen was a former stagecoach driver and took over ranch duties from his father, planting vegetables, alfalfa, and raising cows. He and his wife, Jessie (left), planted olive trees, cured the olives, and sold them. They shipped their vegetables and fruit by wagon to Sacramento, where they commanded high prices. Heintzen's mother, Sarah, is on the right. (Courtesy of Jean Crawford.)

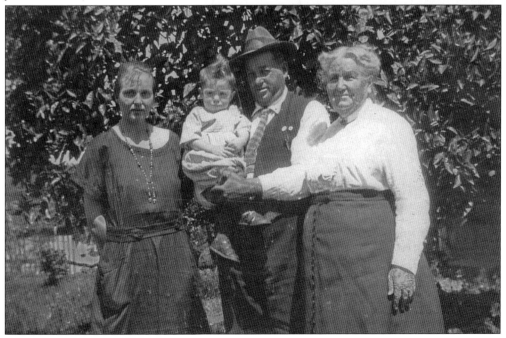

[Handwritten diary excerpt, 1904 — largely illegible cursive]

27	O.O.W. Social dance. Dr. Grants recital in evening he made love to Ida. Cake + Coffee.
nov. 4	Ida B. Laura Plumas + I went for long tramp. Out by Big Sandusky up a ravine over brush, along ridge road, down Ruby Trail. Saw plenty deer tracks.
6	Ida B. + Leon in letter rig. Joe Joe. Left forest for home. Bullards Bar.
7	Met Charlie Scheffer + changed horse. Folks surprised to see me. Joe Ruff here.
11	31 yrs old. 134 lbs. Blue sweater from ma. Hand satchel purse + ? Topaz ring from Leon.
17	Leon + Charlie left for Forest with hogs. I went out in field caught my saddled + rode him. Tended cattle while Leon was away. Riding most every day.
21	Commenced plowing. Ma + I went to ? Had terrible time with Betty the trains struck + bit at me. Threw himself. Had to have men drive across track for me.
23	Jen Ida + I horseback. Joe + J in buggy went to Steam Shovel + Sub Station. ? + I got lost coming home. Lovely moonlight. Dude Derby.
27	Turkey dinner. Jen + Dick. Zetta + Joe + Leon + I. Papa in bed, much better.
19	Went to 10 mile home to mail letters. Charlie went with me. Rode my coming back. Lovely moon lights.
21	Ma + I went to town X mas shopping. Jen worked for men.
24	Xmas Tree, stayed at home all night. Cards for waist from ma. Dick. Ida. Collar + cuffs + ribbon. Zetta + Joe. Collar. Aimee. Haff bag Ella. Comb Josef.

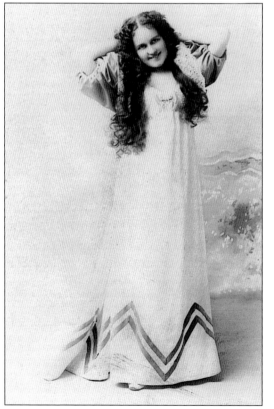

Neighbors along Spring Valley Road not only socialized with each other but also provided willing help when an extra pair of hands or horses was needed. Women were also expected to work on the ranch, as evidenced from this excerpt of Jessie Busch Heintzen's diary from 1904. She describes working with the cattle and being unable to control her horse. At lunchtime, they climbed down from the saddle and put on their aprons. (Courtesy of Jean Crawford.)

This lovely young woman, Zetta Heintzen, played piano to accompany silent films in the rip-roaring days of the Alaska gold rush. She later married J.B. Ruff, a signal electrical engineer formerly of Chicago, Illinois. The couple settled in Yuba County. (Courtesy of Jean Crawford.)

Lita Heintzen, Leon and Jessie's only child, was born in 1896 with a displaced hip. The doctor told her parents that horseback riding would improve the condition. At age 10, Lita excitedly awaited her horse, but it turned out her father bought a mule for her. She was so disappointed that she would not ride it for a long time. She is seen here on the back of the mule. (Courtesy of Jean Crawford.)

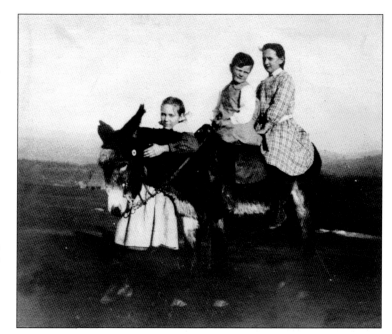

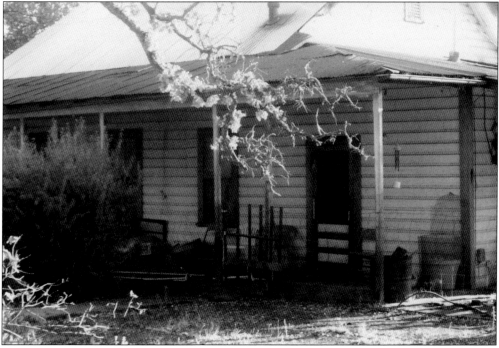

More substantial houses were built, barns were raised, pasture was cultivated, and crops ranging from grapes to alfalfa were planted. Gottfried Zbinden—born in Canton Berne, Switzerland, in 1869— came to California at the age of 20, settling first in Nicholas, where he established a successful dairy of 60 cows. He met young Margaret Breitbach, a native of Germany, and they married in 1899. After moving to Browns Valley in 1905, they continued to raise cattle and hogs and operate a creamery. When the Zbinden family moved into this house on Marysville Road, Chinese laborers grew and maintained truck gardens grown behind the house. (Author's.)

Louise Zbinden, a graduate of Marysville High School, lived her entire life in her parents' house on Marysville Road. (Courtesy of Arthur Rice.)

The three Zbinden daughters are, from left to right, Emma, Louise, and Melba. (Courtesy of Betty Fowler.)

In the 1860s, Duncan Buchanan McMillan set out from Kansas in a covered wagon and homesteaded on the west side of Spring Valley Road. James, Duncan's son, lived on the ranch with his wife, Clara, an 1877 graduate of Marysville High School. They married in 1879 and had nine children, six of whom lived to adulthood. (Courtesy of the McMillan family, Vicki Contente.)

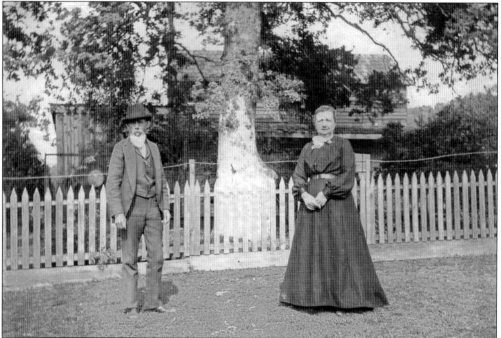

James Enos McMillan and Clara Love McMillan are shown in front of their house. They were stock farmers and grew figs and peaches. All of their children attended Spring Valley School. (Courtesy of the McMillan family, Vicki Contente.)

Two of James's children, Gladys (left) and Arthur, are on their horse in their rock corral. As a building material, rocks were an affordable but labor-intensive means of creating an enclosure. (Courtesy of the McMillan family, Vicki Contente.)

From left to right, Elwood, Clifford, and Cora Lilo McMillan pose for their formal portrait. (Courtesy of the McMillan family, Vicki Contente.)

Spring Valley
Sept. 17, 1898

Dear Lilo;

Gaze on the fleeting moments, make the most of life you may.

What you propose then soon begin it, for life speeds so soon away:

Work and write upon lifes pages, some thing noble, brave, and true that shall say in future, ages; Earth has better been for you:

Your Teacher.

Here is an end-of-school letter that Cora Lilo McMillan received from her teacher, Clara Guerney, of Spring Valley School. (Courtesy of the McMillan family, Vicki Contente.)

The Browns Valley Post Office, established in 1864, has been in continuous operation for 158 years, though it has moved across the road from its original site. For most of that time, it was in the same building as the mercantile company. (Author's.)

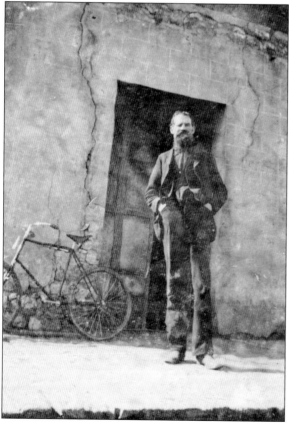

Several well-known pioneers served as postmasters over the years. James Hall, the first postmaster, served from 1864 to 1873; Fredrick Schaeff worked from 1873 to 1882; Walton Cheney McMillan held the position from 1905 until 1908; and pictured here is Byron Burris Sr., who served for 19 years. He, along with T.H. Hibbert, also ran the Browns Valley Mercantile, selling it in 1900. He took up mining full time, establishing the Hibbert and Burris Mine. He owned 500 acres in Browns Valley and Long Bar and was the president of the BVID when he died in 1917. (Courtesy of Ivadene Leach.)

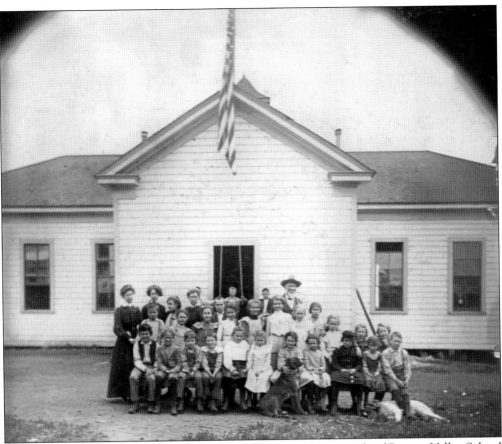

This is the Browns Valley School in 1901 when it was on the west side of Browns Valley School Road. (Courtesy of Arthur Rice.)

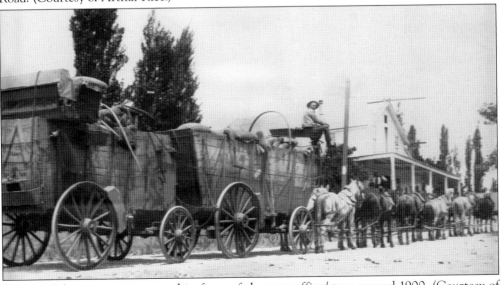

Here, a 12-horse team is stopped in front of the post office/store around 1900. (Courtesy of Ivadene Leach.)

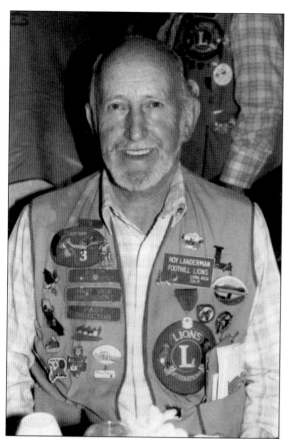

Roy Landerman was a true son of Browns Valley. He loved the area and its people and was always proud of his heritage. Among many other roles, he served as a three-term supervisor for Yuba County's Fifth District and was a prominent real estate broker. (Courtesy of Donna Landerman.)

The Landerman family has been a presence in Browns Valley since around 1850, when 16-year-old Jacob Landerman left Zanesville, Ohio, and signed on as a helper on a wagon train headed for California. This is Ira, Jacob's son, and his wife, Sadie Gleason Landerman. Jacob and his wife bought the Stanfield House, a stage stop, which they operated until the decline of the gold mines. Ira and Sadie established their home down the hill on the West side of what is now Marysville Road. (Courtesy of Donna Landerman.)

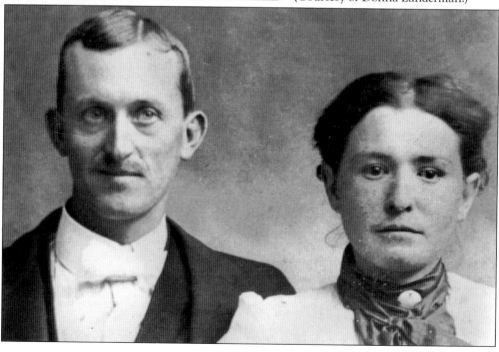

These are the Landerman boys, sons of Ira and Sadie. From left to right are Roy, an unidentified sister, Bob, Carl, Ira Jr., Seth, Arnold, and Lee. As young men, they assumed ranching and truck-farming duties when Ira died at age 58. They raised fruit, vegetables, cattle, and sheep. (Courtesy of Donna Landerman.)

Jacob Sperbeck Sr. came by boat from New York via the Panama Canal, arriving in Browns Valley in 1852. He married Margaret Johnson in 1867. They raised cattle and established the Galena House, a stage stop four miles north of Browns Valley on Marysville Road. The barely discernible handwriting on this marriage certificate illustrates a common spelling variation of the Sperbeck name. (Author's.)

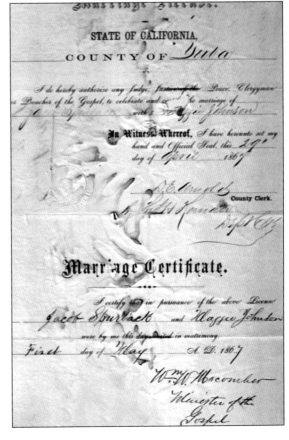

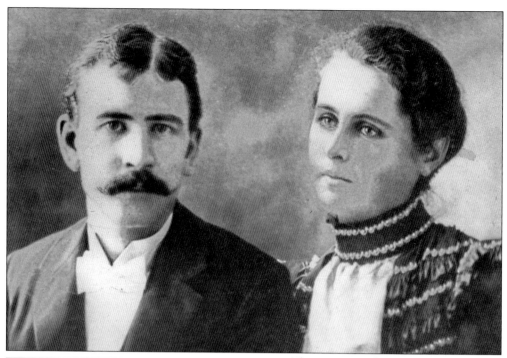

The marriage of Jacob "Jake" Sperbeck Jr. and Nell Gorman in 1897 united two pioneer Yuba County ranching families. Nell's parents, Tom and Hannah Gorman, operated a large cattle ranch on Spring Valley Road and, at this time, owned the Sweet Vengeance Mine. Jake and Nell bought the Ben Amsler place near the Gorman ranch. (Author's.)

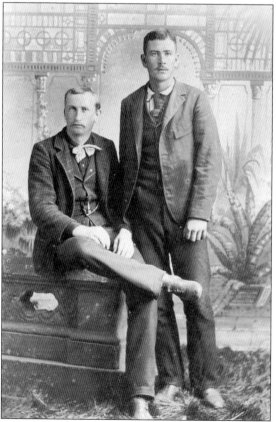

These Butch Cassidy and the Sundance Kid look-alikes, Jacob Sperbeck (right) and Gordie Forbes, were best friends. They worked and played hard. Undoubtedly, this picture was taken before either of them married. The Forbes ranch was east of Browns Valley, farther up in the poison oak and manzanita. Gordie married E. Roby Binninger in 1895. (Author's.)

Four

HOME SWEET HOME

One of the oldest cemeteries in California, Browns Valley Cemetery is so inviting on a hot summer day with its massive oaks, grass, and roses that it became a destination spot for family picnics when the surrounding fields were brown and dry. (Author's.)

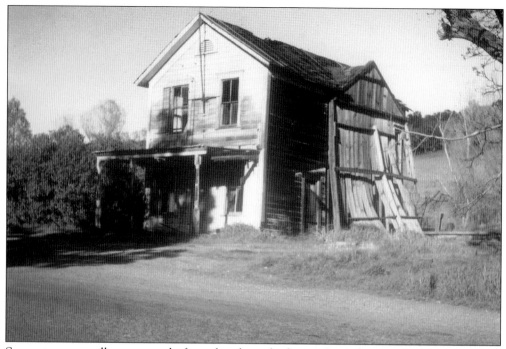

Stage stops were all constructed of wood and caught fire easily. Galena House, Empire House, and Peoria House were among the many that did not survive. Though in disrepair, the Downer House in Browns Valley stood until the 1960s. (Courtesy of Charles French.)

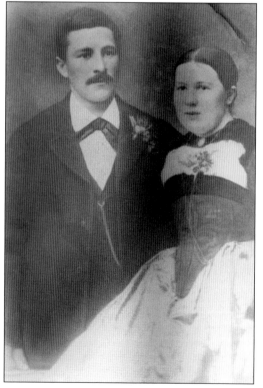

Gottfried Reusser—born in 1869 in Stoffelsrutti, Canton Berne, Switzerland—came to America in 1890, settled in Ohio, and then moved to Nicholas in Sutter County in 1891. He returned to Switzerland, married Rosa Burke, and moved to Browns Valley in 1901, becoming superintendent of the Empire Ranch on the east end of Spring Valley Road. He and Rosa raised five children, and when Rosa died in 1916, he remarried and had three more children. He eventually purchased the 373-acre ranch and built a house. This picture was Gottfried and Rosa's wedding photograph. (Courtesy of Arthur Rice.)

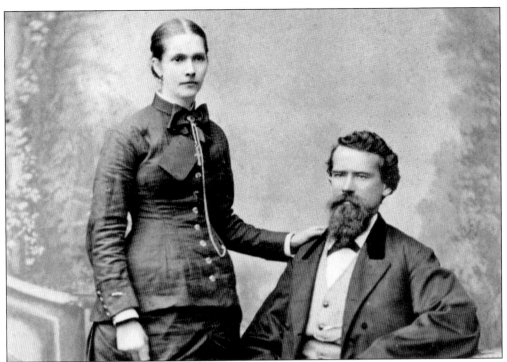

Swearingham Burris, a lead miner, farmer, and dairyman from Ohio, traveled with his wife, Hannah, across the plains to California in 1849 with all their possessions. First homesteading in Camptonville, they later moved with their son Joe to a ranch on what is now Fruitland Road. They paid $500 for 160 acres, eventually adding more acreage until they owned 700 acres. (Courtesy of Community Memorial Museum of Sutter County.)

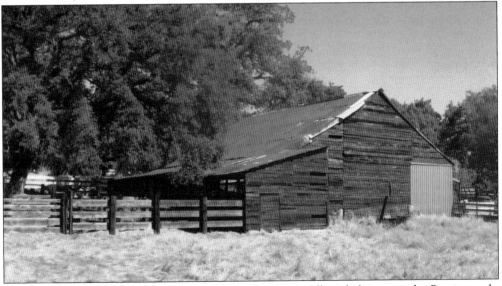

This barn, built by Swearingham Burris around 1860, is still in daily use on the Burris ranch. Held together with mortice and tenon, it is huge and was sturdily built with lumber from an old hotel in Browns Valley. Repairs have been done, the original shake roof has been replaced with tin, and the barn has never burned. (Author's.)

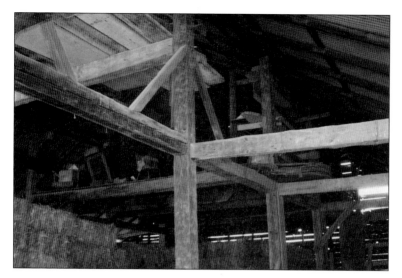

The supporting beams in the old Burris barn are fastened together with old-fashioned mortice-and-tenon construction, which provides decades of stability with little need for repair. The platform with furniture on it was added in later years. (Author's.)

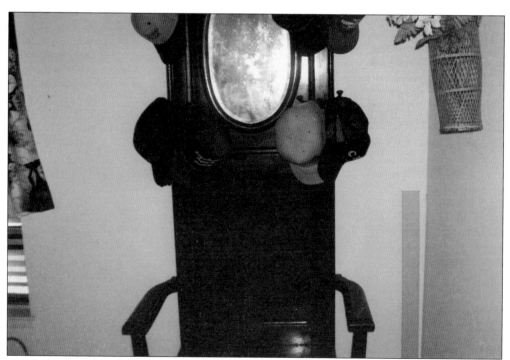

This hall tree came across the plains with Hannah and Swearingham in their wagon. It graced the family home for many years until Hannah died in 1893, when it disappeared. Decades later, it was uncovered under stacks of furniture in a relative's attic as the room was cleaned after his death. Ethel Rose Burris, a granddaughter-in-law of Hannah, recognized the family hall tree, and it now occupies pride of place in her grandson Ray Hoxworth's living room, decorated with modern-day baseball caps. (Author's.)

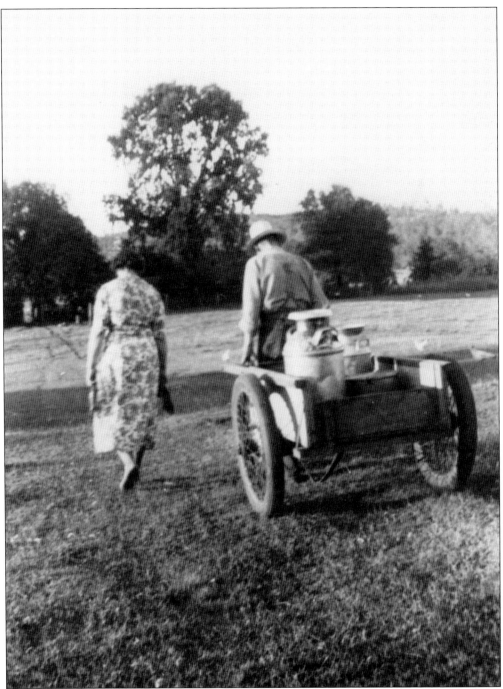

Cream and butter were luxuries that were absent from the mining towns and settlements of the West Coast, so many families began small dairies to provide milk products for themselves and to help bring in some income. As technology evolved, milk could be kept cool until it could be picked up. Joe French and his wife, Martha Louisa, are taking milk down to the separator shed to be separated until the cream can be picked up by a Gridley creamery. Each part of the process involved hard work. Excess milk was fed to the hogs or chickens. (Courtesy of Charles French.)

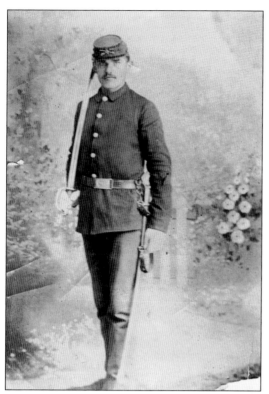

Born in 1869 in Iowa, Ruel Hendricks came with his parents to Browns Valley in 1874. As a young man, he worked on the dredger in Hammonton, was a cattle rancher, and was proprietor of the Browns Valley Mercantile. Ruel was a trustee for the Browns Valley School, built his house behind his store, and constructed and operated the Fuchsia Creamery on the east side of his house. He was a loved and respected Browns Valley pioneer. (Courtesy of Ivadene Leach.)

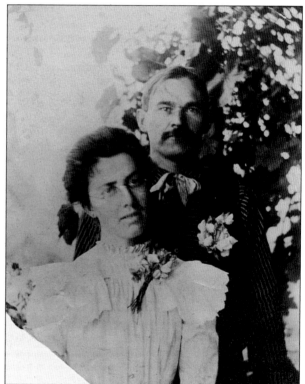

This is the wedding photograph of Ruel and Ethel Hendricks. Ruel was gregarious, outgoing, and active in the community, and Ethel was shy and retiring, preferring to stay home with their children. (Courtesy of Ivadene Leach.)

The house Ruel Hendricks built behind the creamery for his bride is gone. This house, built about 100 years ago next to the creamery, is one of the few remaining old houses in Browns Valley. (Author's.)

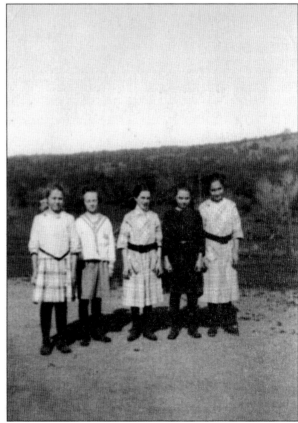

From left to right, Carol Hendricks, Esther Fitzgerald, Melba Fitzgerald, Mabel Hendricks, and Ruby Fitzgerald pose for the camera at Peoria School. (Courtesy of Ivadene Leach.)

Ted Dodson married Ruel's daughter Carol and lived in Browns Valley for the rest of his life. When Ted was around 15 years old, he and Clyde Burris were known to be fun loving, high-spirited best friends, but trouble often followed them. One bright spring day, they sneaked a pistol out of the house and went up to Red Hill for target practice. Unfortunately, Clyde accidently shot Ted in the leg at close range, severing his bone and tendons. Ted's leg healed after a long hospital stay, but he was left with a pronounced limp, which prohibited him from working in the mines. For years, he drove concentrate to the mills in Grass Valley. He and Clyde remained best friends. (Courtesy of Ivadene Leach.)

Johnny Reusser, Gotfried and Rosa's son, is shown here in his World War I uniform. After the war, Johnny married Eva Rice, and they lived at Daguerre Point, where he worked on the dredger. They had three children under the age of seven when Johnny was electrocuted while laying some iron pipe for a neighbor. (Courtesy of Arthur Rice.)

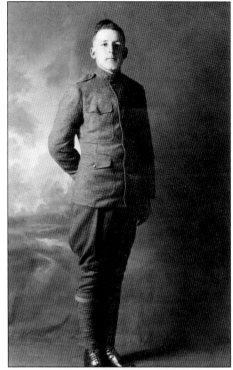

Here is the original Rice family home on Bald Mountain Road, where family members have lived since 1860. Eva Rice Reusser moved back here with her children after her husband was killed. She continued to teach school. (Courtesy of Arthur Rice.)

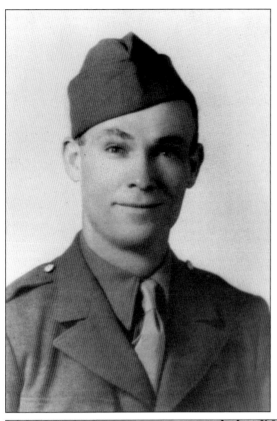

Jess Rice is in his World War II uniform. Jess left his home on Bald Mountain Road to join the Army and was stationed 20 miles away at Camp Beale. He had spent six months there when the war ended and he returned home. He always appreciated the medical benefits and other veteran services he received as a result of his service even though he did not see distant lands. (Courtesy of Arthur Rice.)

People all over the United States made sacrifices for the war effort, and Browns Valley was no exception. Some food and gasoline was rationed and had to be bought with these ration books. There was no butter to buy, so margarine was invented, and little packets of yellow coloring were added to the white greasy substance. (Courtesy of Arthur Rice.)

662163 K

4

UNITED STATES OF AMERICA
OFFICE OF PRICE ADMINISTRATION

WAR RATION BOOK FOUR

Issued to *Joseph L. Rice Jr.*
(Print first, middle, and last names)

Complete address *Brown's Valley, Calif.*

READ BEFORE SIGNING

In accepting this book, I recognize that it remains the property of the United States Government. I will use it only in the manner and for the purposes authorized by the Office of Price Administration.

Void if Altered

(Signature)

It is a criminal offense to violate rationing regulations.

OPA Form R-145

16– 35570–1

When Joe Rice married Rosalie Reusser, they settled down on the Empire Ranch his grandfather had established by at the eastern corner of Spring Valley and Marysville Roads. As a young man, he made the long trip to Decatur, Iowa, to attend Palmer School of Chiropractic. After graduation, he returned home but never practiced as a chiropractor. (Courtesy of Arthur Rice.)

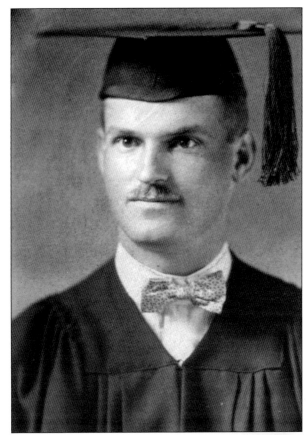

The house built by the Richard Rice family is in the same spot as the old home place on Bald Mountain Road and is an exact replica. Today, it is the site of the Bald Mountain Nursery owned and operated by Cecilia Rice and her son Jeff, a fifth-generation Californian on the family property. (Author's.)

These children are the fourth generation of the Rice family. Joe and Nancy are in back, and Arthur (left) and Alice are in front. The large Rice and Reusser families have been a mainstay in the Browns Valley community for generations. (Courtesy of Arthur Rice.)

Charles Reed Scott came from Edinburgh, Scotland, via Canada, arriving in the United States in 1850. He and his wife, Ellen Haley, of Ontario, Canada, whom he married in 1863, opened a butcher shop in Poker Flat. Because Charles continued to mine in Sierra County each summer, he knew a butcher shop was needed there and opened a second location in Downieville. Charles and Ellen had nine children, six of them lived to adulthood. (Courtesy of the Scott family.)

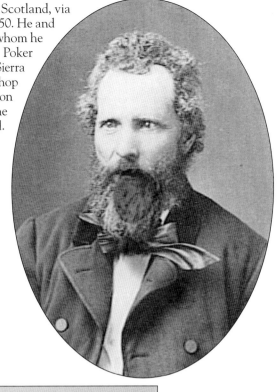

In 1910, Charles and Ellen's sons James, Charles, Walter, and Robert acquired close to 1,000 acres of ranch land (about 10 miles northeast of Browns Valley on Township Road) and stocked it with Durham cattle. They also continued to mine and shared ownership of property called Tennessee Gulch in Poker Flat. This is the original house on the Scott ranch. (Courtesy of the Scott family.)

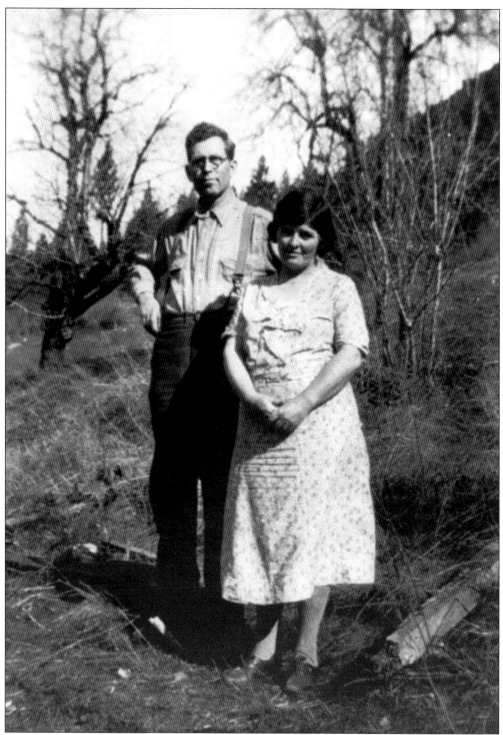

Rob Scott married Nettie Carmichael, a member of another large and old ranching family in Sierra County. They continued to operate the butcher shop in Downieville and were partners with his brothers in the ranch at Browns Valley. (Courtesy of the Scott family.)

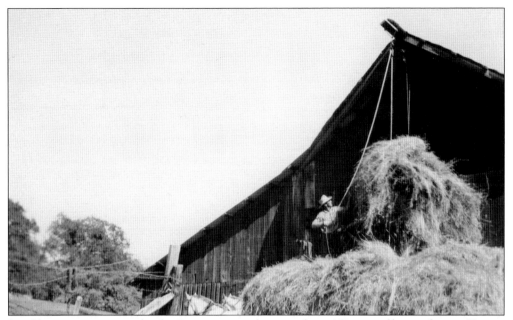

In addition to raising cattle, the Scotts grew and put up about 150 tons of hay each year. Haying is one of the hardest, most labor-intensive jobs known to man. Planting the seeds, cultivating, and cutting were all done with teams of horses or by hand. It is usually very hot when it is time to cut and store it in the barn. (Courtesy of the Scott family.)

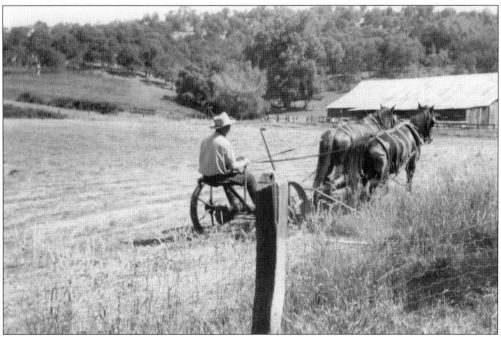

Horses Tom and Jerry are working to cut hay on the Scott Ranch. (Courtesy of the Scott family.)

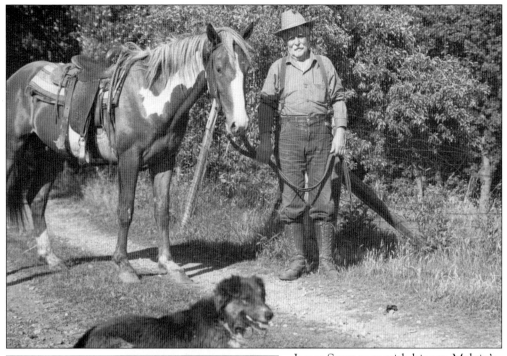

James Scott rests with his son Melvin's horse, Paint, and Tipper after a hard day's work on the ranch. Melvin bought Paint at auction, employed him as his favorite workhorse for 32 years, and resold him at auction for the same amount. Paint loved pancakes and always received an ample supply. James's granddaughter Melba believes that her father could not bear to see Paint die on the ranch. (Courtesy of the Scott family.)

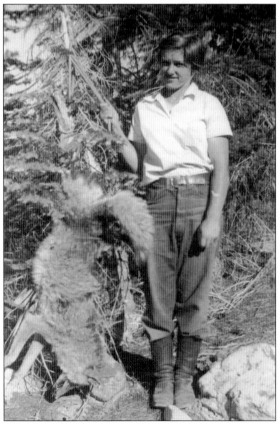

Ethel, James's daughter, is proudly displaying a coyote she shot on the ranch. Most ranchers abhor coyotes, believing they are a constant threat to any small or recently born animal. (Courtesy of the Scott family.)

William Tell "W.T." Binninger was a commissary sergeant in the Mexican War of 1846. An 18-year-old boy from Ohio, he drove his team of oxen to Mexico. When the war ended, he came to California and reunited with his father, Jacob, whom he had not seen in 12 years. They partnered on building a successful hotel in Sacramento and then both moved to Browns Valley. (Courtesy of Lou Binninger.)

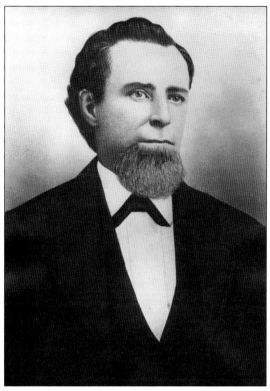

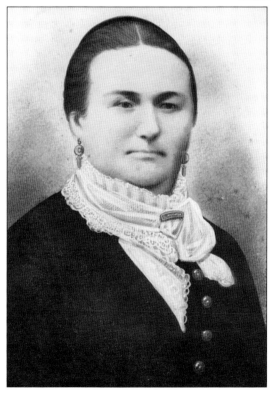

Dorothea Gunderman of Sacramento was born in 1834 in Germany, married William Tell Binninger in 1851, and moved with him to Browns Valley. (Courtesy of Lou Binninger.)

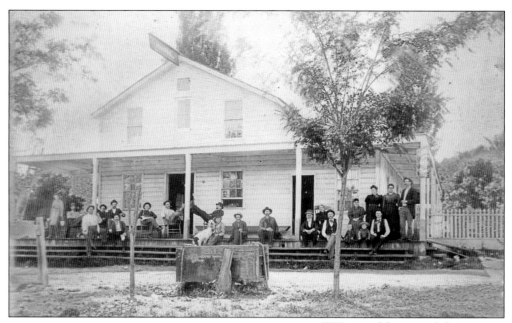

W.T. joined forces with his sister Elizabeth to build and operate the Empire House in Browns Valley, a successful stage stop and hostelry for many years. Col. John Sutter, an old friend of W.T.'s from his days in Sacramento, was a frequent visitor at the Empire House, where they sat on the wide porch, discussing the grapes growing across the road and the sad state of political affairs in California. This is one of the stage stops on Marysville Road. (Courtesy of Lou Binninger.)

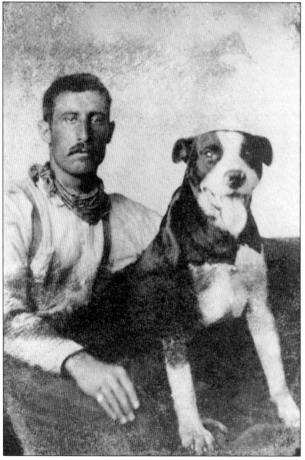

Louis Dix Binninger, W.T.'s youngest child, was born at Summit House north of Dobbins in 1875. Louis was a cattle and sheep rancher who married Anna Elizabeth Sperbeck, a daughter of Jacob and Margaret Sperbeck. M.H. Binninger, W.T.'s fourth child, who was born at Empire House, eventually took over his father's business. (Courtesy of Lou Binninger.)

Five

THE STORIES UNFOLD

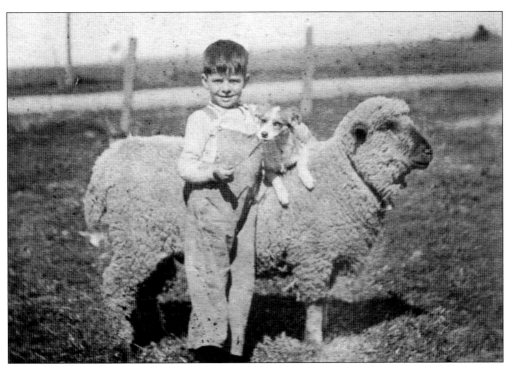

Eldon Binninger, born in 1913, was Louis and Anna's youngest son. Benny, as he was known, was a prominent butcher in Yuba County. He worked as a meat cutter for Valley Meat for many years before opening his own butcher shop on Twelfth Street in Marysville in the 1950s. Every child who accompanied his or her parents into Benny's Meat Market received a free frankfurter. (Courtesy of Lou Binninger.)

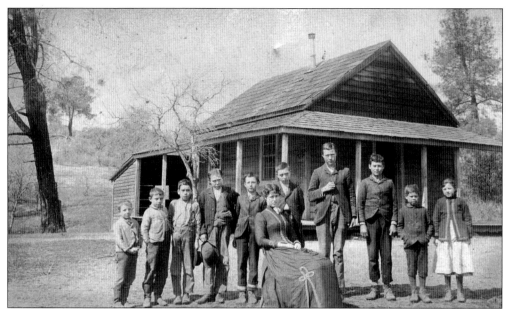

Bald Mountain School was built on top of Colton Hill on the west side of Peoria Road. Teacher Alice May Hedger (sitting) and students gather for this picture in 1889. From left to right are Sidney Bennett, James Bennett, John Payne, Hiram Richard, Arthur Scott, George Payne, George Richard, John Scott, William J. Labadie, and Mary Bennett. Alice May married John Rice in 1889 and lived in Browns Valley the rest of her life. (Courtesy of Arthur Rice.)

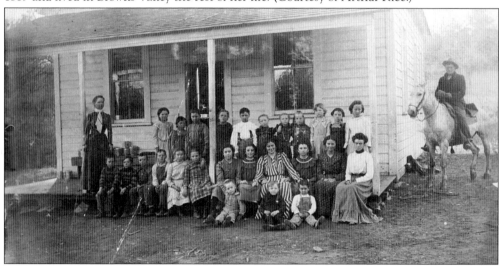

This second view of Bald Mountain School was taken around 1910. From left to right are (first row) Clarence Binninger, Orin Pieratt, and Elmer "Tiny" Binninger; (second row) Bert Binninger, Harlan Pieratt, Preston Hendricks, Isaac Loveless, Mattie Hendricks, Josephine Nelson, Mattie Binninger, Edith Binninger, Blanche Loveless, Frances Binninger, Grace Loveless, and Minola Loveless; (third row) Eva Rice, Arthur Rice, Everett Colton, Johnny Reusser, Charles Binninger, twins Violet and Virely Loveless, Cora Rice, Del Loveless, unidentified, and Gladys Loveless. The teacher, at far left, is Miss McCarthy, and Forrest Matson is on horseback at right. For students such as these, school could be a welcome respite from the chores they were responsible for at home. (Courtesy of Lou Binninger.)

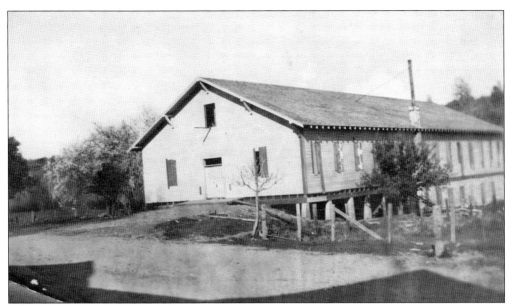

The Browns Valley Community Hall was the social center for the community in the early part of the 20th century. Community events were held here, and when family and friends got together, the walls rang with music and laughter. Babies slept in wicker baskets at the edge of the dance floor. (Courtesy of Ivadene Leach.)

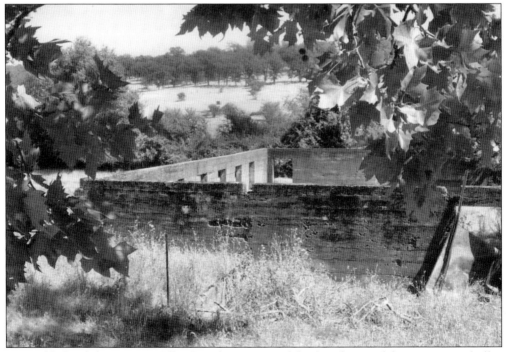

Located behind the Browns Valley Bar, this portion of the foundation of the community hall is all that remains today. (Author's.)

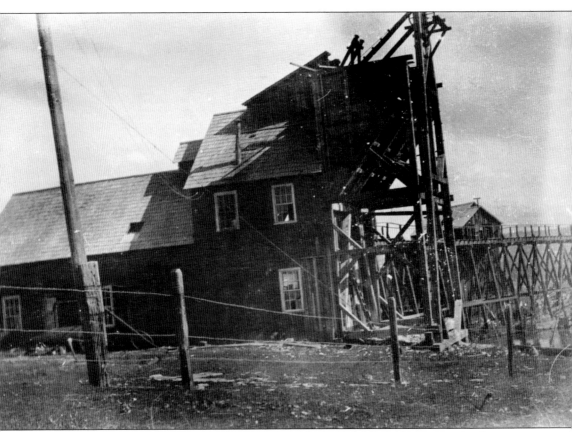

Manuel E. Silva, the son of Manuel D. Silva, an immigrant from St. Georges in the Azores, was born in 1866 in Nevada County. Manuel D. arrived in San Francisco via Cape Horn after working on a whaling ship for seven years. He joined the gold rush in Placer County and moved on to Nevada County, where he worked in this mine. The name of the mine is unknown. (Courtesy of Ed Silva.)

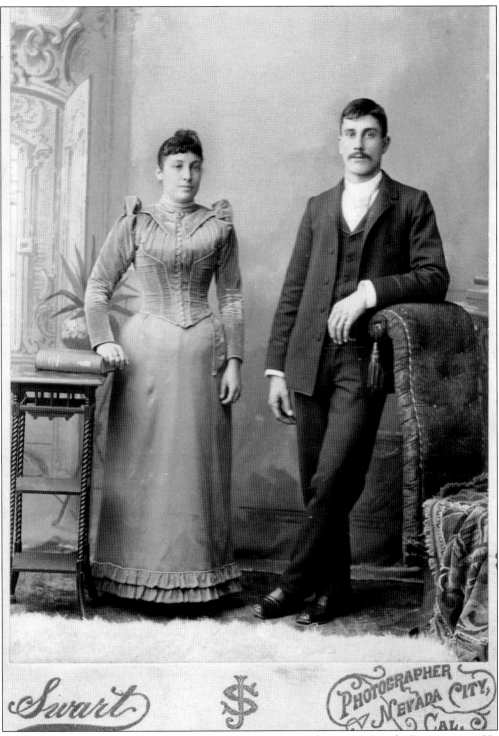

Manuel E. Silva began in the mining business at age 16, working at a Nevada County mine. He married Rosa, the daughter of Nevada County pioneer miner Henry Silva. Manual and Rosa had four children: Katherine, Clarence, Ed, and Martha. (Courtesy of Ed Silva.)

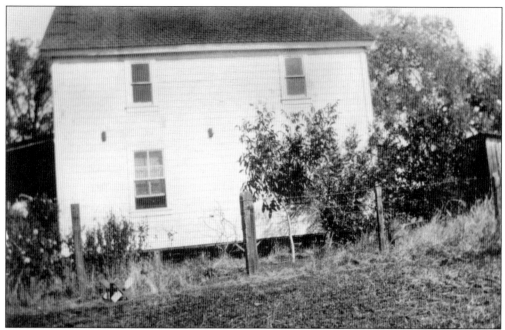

After 30 years in the mining business, Manuel bought 261 acres in Browns Valley on Marysville-LaPorte Road and began raising dairy and beef cattle. He built this house across from the Meister dairy. Manuel served for nine years as a Peoria School trustee. (Courtesy of Ed Silva.)

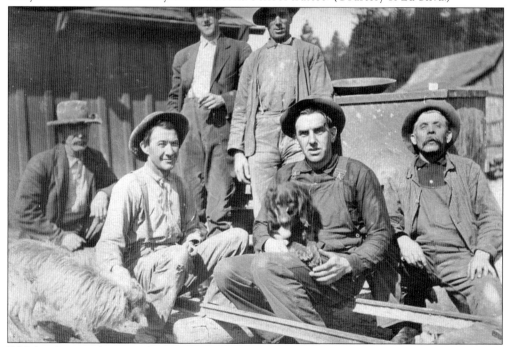

Ed Silva Sr., standing at right, is Manuels's son. Here, he is working at the same mine his father and grandfather had worked in Nevada County. Ed Sr. lived a long and productive life as a rancher after he gave up mining. The Browns Valley community helped him celebrate his 100th birthday at the Loma Rica Lions Club. He lived to be 105. (Courtesy of Ed Silva.)

This century plant is blooming on the old Silva ranch. Originally thought to bloom every 100 years, in reality, these agaves from Mexico live for about 10 to 30 years, flower once, and die but send up new shoots. (Courtesy of Ed Silva.)

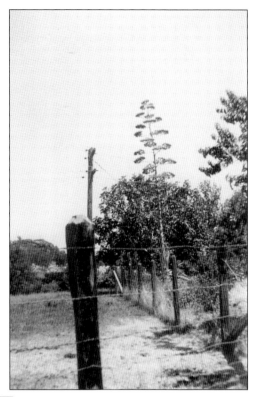

Ethel Burris's granddaughter was Marion Emory, and at about the age of 11, she came to live with the Burris family on the ranch and spent the rest of her teenage years there. Ed Silva was foreman of the ranch and became acquainted with Marion when she was a teenager. They married and had four children. Shown here are their three girls, Elvera, Virginia, and Katherine. Their son, Ed Jr., is not shown. (Courtesy of Ed Silva.)

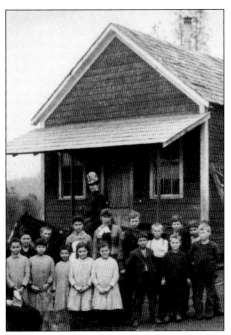

This picture of Peoria School was taken around 1891. The second person from the right in front is James Harding, who was born in 1882 and lived for 100 years. He appears to be about eight years old here. There were four locations of Peoria School, and four different buildings housed the school. The first site sat between two oak trees in the center of the field across the road from the present site. The second site was at the top of the little hill behind and to the west of the present site, and the third location was over on Marysville Road, halfway up the hill north of Peoria Cemetery. Wood stoves in the center of the room heated the three buildings that burned down. If these stoves had a roaring fire, paper or debris in the chimney pipe caught fire, and the building went up in flames. (Courtesy of Dick Springsteen.)

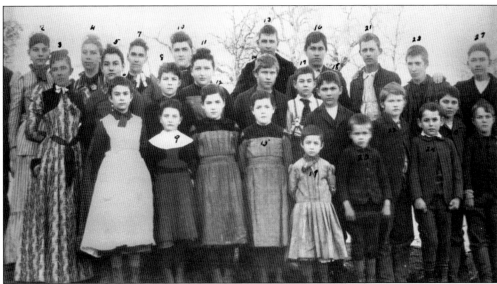

The students at Peoria School dressed up and posed for this photograph in 1892. At this time, the school was north of the Peoria Cemetery, almost directly across from what is now Fruitland Road. Pictured (from left to right, back to front, and numbered according to the image) are Maggie Sperbeck (2), teacher Josie Sheehan (3), Jennie Dolan (4), Ann Sperbeck (5), Josephine Sperbeck (6), Arthur Bady (7), Mabel Williams (8), Mamie Sperbeck (9), Annie McMahen (10), Rose McMahen (11), Alice McMahen (12), Jake Sperbeck (13), Charley Harding (14), Mary McMahen (15), Richard Harding (16), John Sperbeck (17, wearing suspenders and tie), Frank Harding (18, in front of and slightly right of John Sperbeck), Esther Sperbeck (19), Ira Landerman (21), Fred Harding (22), Golden Finnemore (20), Morris Kane (23), John Harding (25), Leonard Williams (24), James McMahen (27), and James Harding (26). Bill Williams (1) is not shown. (Courtesy of Lou Binninger.)

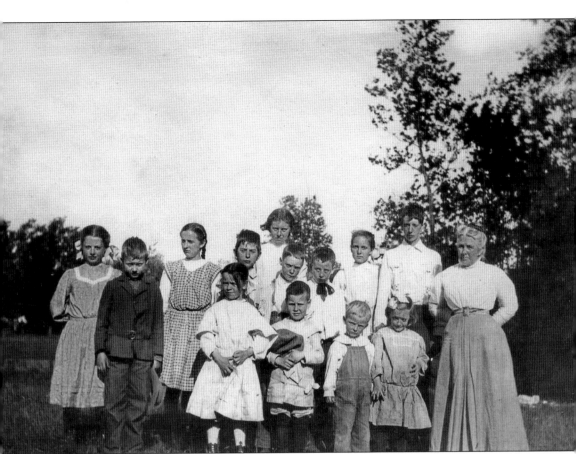

Annie Sperbeck, the daughter-in-law of Jacob Sperbeck Sr., is the teacher in this Peoria School photograph from around 1918. Peoria School was one of the earliest schools formed during the Gold Rush. Around 38 students enrolled in 1854 when the school was established. (Author's.)

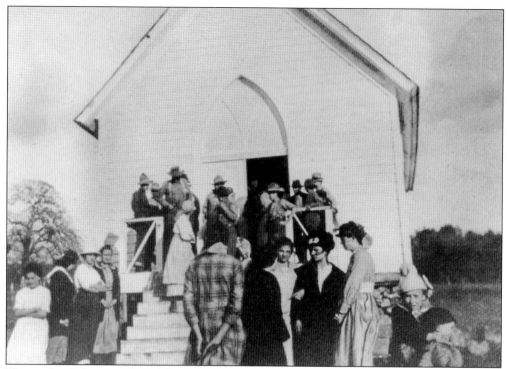

This undated photograph is of the Peoria Church, which used to sit just north of the cemetery. It is known that when the funeral of Charlie Sperbeck's wife, Anna Pettit Sperbeck, was held here, so many people attended in honor of the longtime, popular teacher that the floorboards of the church broke, and the remainder of the service had to be held outside. (Author's.)

Today, Peoria School is the home of the Dick Springsteen family. This building, which has never burned, was built around 1902. (Author's.)

Laura Marvin was well known to generations of schoolchildren in the Browns Valley area. Marvin taught at Peoria School until it closed and then finished up a 40-year teaching career at Loma Rica School. She is holding her great-great-niece Janice Loughran. (Courtesy of Myrna Gee.)

When Joseph French and his wife came to Browns Valley in the 1930s, they bought 40 acres from the Binninger family on the east side of what is now Marysville Road, one mile above Dry Creek. They worked this acreage with their son Cecil and his wife, Dona. Joe established a dairy, milking 10 to 15 cows, and planted alfalfa to provide hay for his cows. (Courtesy of Charles French.)

Four-year-old Robert "Bob" French is astride one of Zbinden's plow horses, with his grandfather Joe looking on. Bob was a happy-go-lucky child until he contracted poliomyelitis, just as the Salk vaccine became available to schoolchildren. He was the school photographer for Marysville High School in his senior year when he became sick. He became paralyzed and died three months later. (Courtesy of Charles French.)

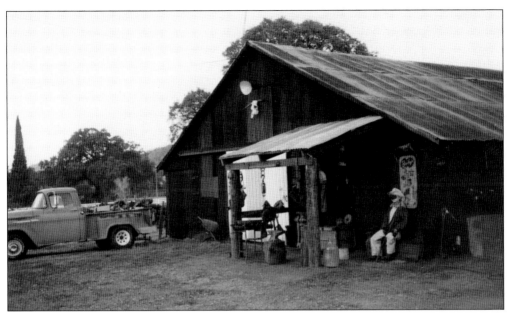

This barn, one of the oldest in the region still in daily use, burned in the 1930s and was rebuilt by Cecil French and his father. Fourth and fifth generations of California French family members still make their home on the original property. (Courtesy of Charles French.)

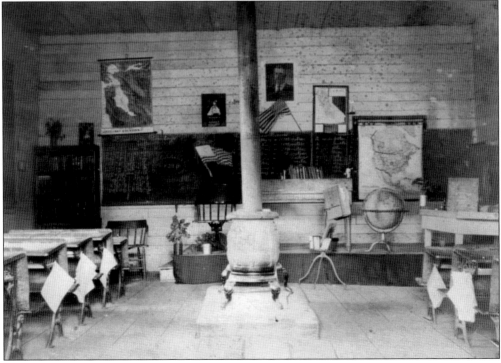

A rare photograph taken around 1914 reveals the interior of the Spring Valley School on Spring Valley Road, just west of the Sweet Vengeance Mine. This school was moved from the south to the north side of the road, where it remained until it was demolished in the 1970s. (Courtesy of the McMillan family, Vicki Contente.)

Flora Burns came from Berkley in 1921 to fill the vacancy at Spring Valley School after graduating from San Francisco Normal School. She boarded with the Tom and Margaret Gorman family, the owner of the Sweet Vengeance Mine. (Author's.)

Lloyd Sperbeck, age 21, models his chaps. Tom and Margaret Gorman's grandson was well on his way to becoming a cattleman in his own right and knew how to look the part. He became acquainted with Flora Burns, his grandparent's boarder, and they married in 1923. (Author's.)

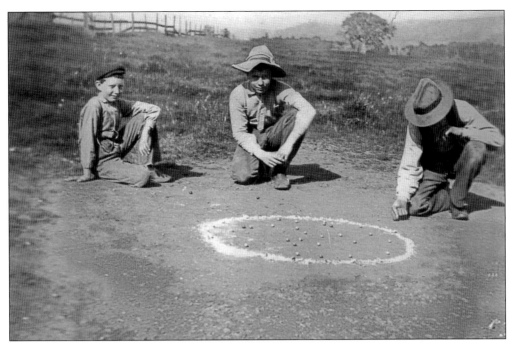

Clifford McMillan, center, seems confident of his marble-shooting skills. The boys demonstrate the appropriate apparel, with hats and all, for marble shooting in 1900. (Courtesy of the McMillan family, Vicki Contente.)

<u>23</u>

April 12, 1929: We worked on our fair work today. The teacher told the first, second and third graders about the health fairy that was going to visit them.

April 15, 1929: Tomiko and Buddy seemed to enjoy themselves while playing baseball. Instead of helping their side they went walking arm in arm and sat under the shady tree. The first, second and third are making pretty pictures to put on the window.

April 16, 1929: We practiced songs, recitations, and speeches for our aggie club meeting that is going to be tomorrow. We went to the mine today and played.

April 17, 1929: Mrs. Hientzen came to our aggie club meeting. She told us about the Ag Banquet which is going to be in May. When Haruko called the roll Dorothy said, "president" instead of "present." After the meeting we played games.

April 18, 1929: Mrs. Sperbeck put up a Safety First Picture on the wall this morning. We played baseball while it was raining so the teacher rang the bell to make us come in.

April 19, 1929: We wrote Kind Deed Stories during language period. The boys worked on their bird houses.

All the students at Spring Valley School in 1928 and 1929 decided to keep a diary of the momentous occasions and exciting happenings of the school year. The students are Gwen Barrie, Dorothy Crawford, James Crawford Jr., Robert Crawford, Eugene Collins, Alice Iseri, Anna Iseri, Hazel Iseri, Gerald Rice, Norma Rice, and Melba Zbinden. (Author's.)

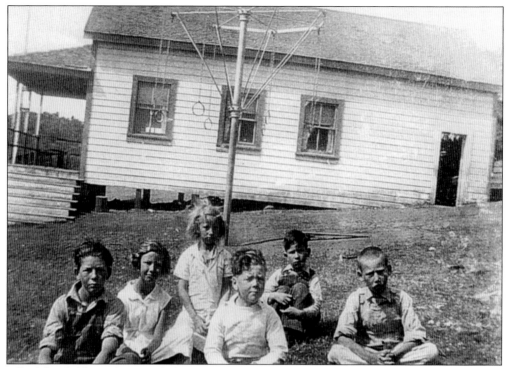

All of the children who attended class this spring day in 1930 pose for a picture on the east side of the school. The only one easily identifiable is seven-year-old Lloyd Sperbeck Jr., who is fourth from the left. (Courtesy of Betty Kunde.)

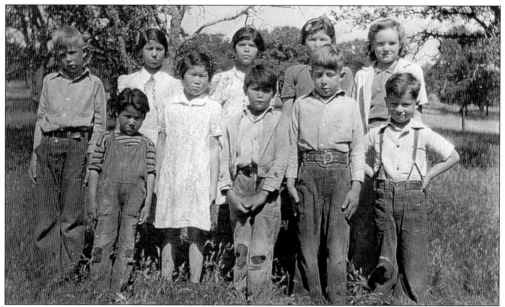

During the 1930s, in the depths of the Great Depression, children who did not have food to eat at home came to school. According to former student Betty Pickett Kunde, teacher Sperbeck and parents Mary Pickett and Dona French took turns bringing beans, bread, and other hot dishes to the school to feed all the children. (Author's.)

This is the student body of Spring Valley School around 1940. Teacher Flora Sperbeck is in the back (center); June Welch is on the far right in the front row; Charles French (wearing suspenders) is in the center of the second row; Jim Welch is to Charles's left, behind the boy in the cone hat; and Betty Pickett is in the center of the third row, wearing a dark shirt. The remaining children are unidentified. (Courtesy of Betty Kunde.)

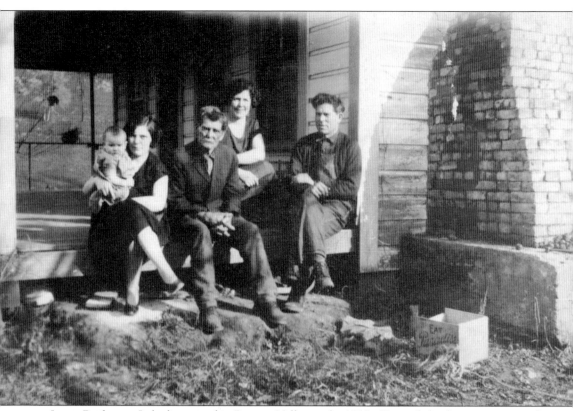

James Buchanan Labadie arrived in Browns Valley in the 1920s. He made his living raising cattle and sheep. Here, he sits third from the right with son William (far right) and daughter Vivien George (second from right) on the steps of the oldest Labadie house he built on Peoria Road. The woman and child on the left are unidentified. (Courtesy of David Labadie.)

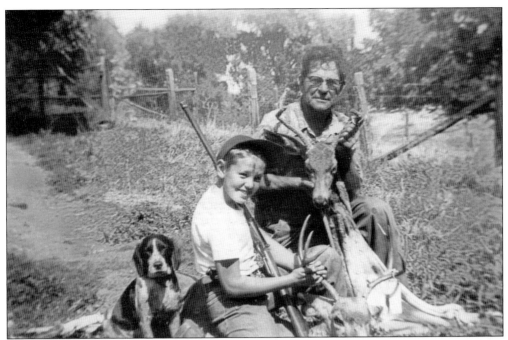

James's son Will is shown with his grandson David Labadie (age 11), who has shot his first buck. When a child lives in the country and comes from a family of hunters, it is a major event for a young person to kill their first deer. Browns Valley has long been a hunting destination for deer, turkey, and small game hunters. Even an occasional bear has been stalked and slain here. (Courtesy of David Labadie.)

David Labadie is sitting on the steps of the house his father and grandfather built on Peoria Road. They used the lumber salvaged from Bald Mountain School on Colton Hill when the school was torn down. Flooring and walls were dragged down the steep hill by horse-drawn wagons and put to good use. "Make do or do without, use it up, wear it out" was a philosophy in which early settlers believed. Using rocks as foundation and decoration was common in the foothills. Benefits were twofold: freeing up pasture space by clearing the field and providing strong, sturdy foundations and attractive fireplaces. (Courtesy of David Labadie.)

Sidney "Sid" VanUxem Smith was born in 1881 in San Francisco to well-to-do parents. He was discharged from the service near the end of World War I. Gregarious and social with many friends, he found himself at loose ends when he returned to San Francisco after the war, so the Smith family purchased a beautiful 480-acre ranch east of Hammon Grove in 1920. Sid made his home on the rolling hills with vistas of pastureland. Not surprisingly, he was the only rancher from Browns Valley listed in the 1932 San Francisco Social Register, a who's-who list of the socially elite. (Courtesy of Henry Smith.)

With its proximity to Dry Creek and to the Yuba River, the Smith ranch had readily available water. Here, ditches are being dug with a team of horses dragging a flat iron. (Courtesy of Henry Smith.)

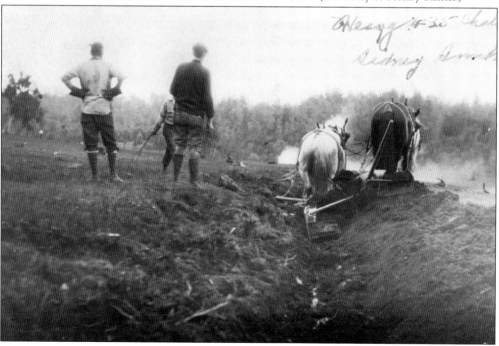

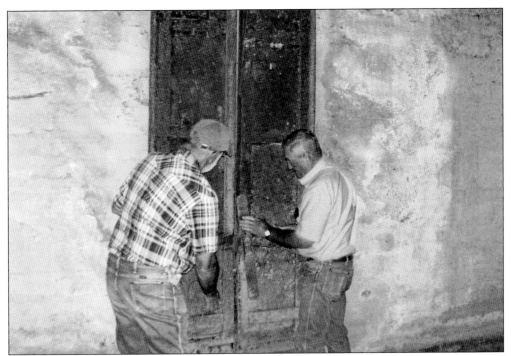

One of the first crops Sid VanUxem Smith planted on his ranch was 200 acres of grapes. This turned out to be a fortuitous choice since the country was enduring 12 years of Prohibition. Friends from Marysville and Grass Valley came to the ranch to help pick and stomp grapes, bottle the wine, and then enjoy it. This wine storage cellar is sunk into the hillside on the ranch. Henry Smith, right, and Roland D'Arcy, left, struggle to open the massive doors leading to the well inside the wine cellar. (Courtesy of Henry Smith.)

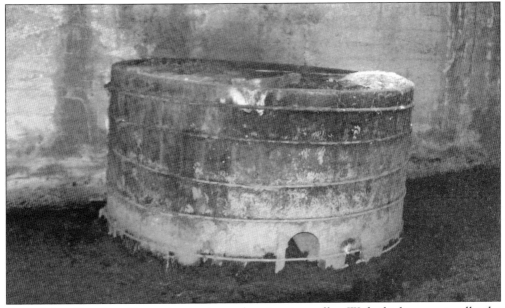

One of the old casks still remains in the cool moist wine cellar. With thick cement walls, the cellar remains at a constant temperature year-round. (Courtesy of Henry Smith.)

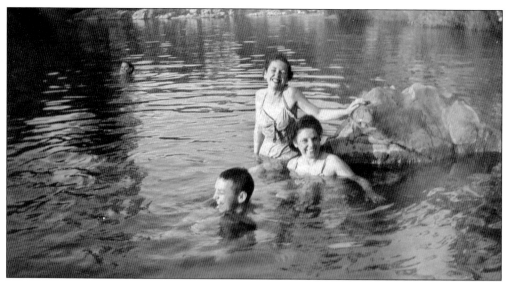

Long before there were private swimming pools, people swam in streams, lakes, canals, and ponds, basically wherever one could get cool on a hot summer day. Sid Smith's reservoir in Dry Creek, along Peoria Road, was one of the most popular swimming holes in Browns Valley in the 1940s and 1950s. Teenagers had parties here, far from their parent's watchful eyes, and whenever people went to swim, they met their friends and neighbors. Swimming here are Sid's children: Henry, Mona, and Donna (in the back with her hand on a rock). The person behind and to the left of them is unidentified. (Courtesy of Henry Smith.)

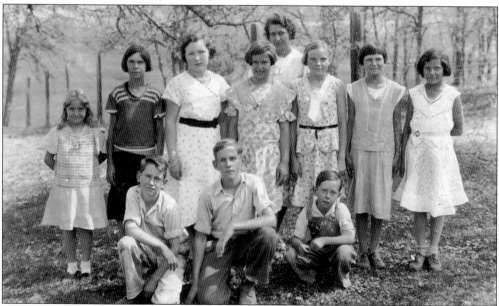

Long Bar School had a long history from its beginning in 1854, when it had 54 students and Long Bar was a thriving town. Eventually, in the late 1940s, students were absorbed into the Browns Valley School. Here, (first row) Rupert Handy, Chester Handy, and Frank Handy; (second row) Beatrice Galloway, Alice Shoemaker, Gladys Beaver Poor, Ethel Beaver, Katherine Tanner, Martha Shoemaker, and Dorothy Shoemaker are seen taking a break from their books in 1930. The teacher in the back is unidentified. (Courtesy of Scott family.)

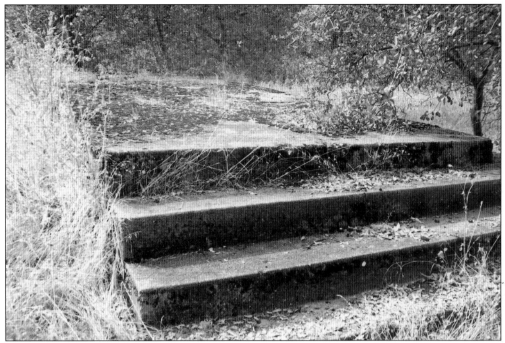

These steps, along with the remnants of a cistern, are all that remain of Long Bar School today. Hay was stored in the school building when it burned in 1950. (Author's.)

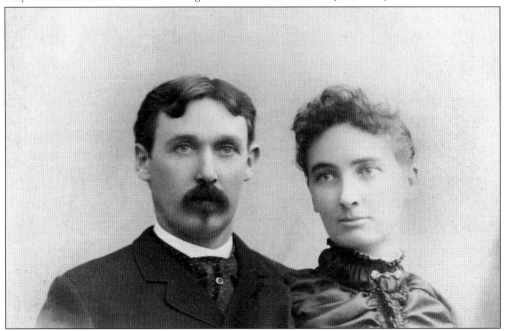

Natives of Ireland, the Yore families immigrated to the United States, settled in Illinois, came by land to California in the gold migration, and established Sleighville House in Sierra County, where Peter was born in 1863. John Yore, one of 13 children of Pete and Eliza Yore, is pictured here with his wife, Laura. He was the manager of the Sierra Turnpike Company in Sierra County. (Courtesy of Beverley Wooten.)

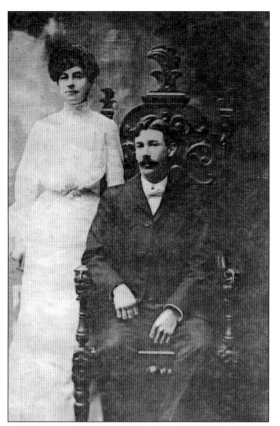

Fred Yore, one of John Yore's four children, is shown here in his wedding photograph with his bride, Alpha Wilder. Fred was a well-known cattleman in both Sierra and Yuba Counties. Fred and Alpha built a house on Spring Valley Road around 1935 and lived there almost 30 years. (Courtesy of Beverley Wooten.)

Fred and Alpha Yore moved to Gooding, Idaho, in the early 1960s and continued raising cattle with their son Jack and his family. Alpha was gifted in gardening and baking, growing a profusion of geraniums around her house and making delicious bread. (Author's.)

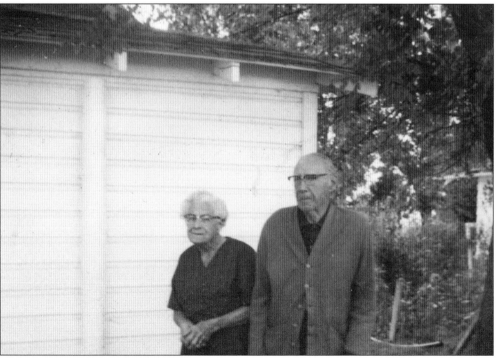

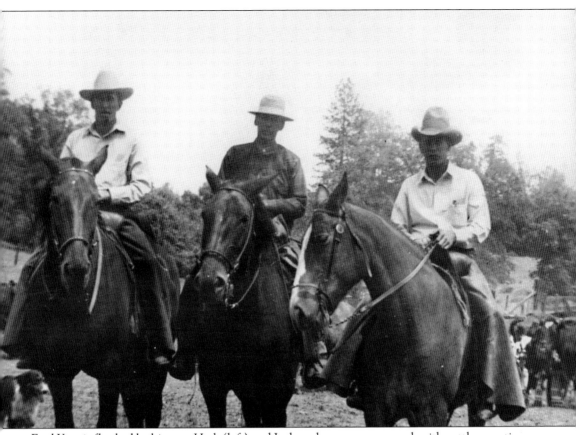

Fred Yore is flanked by his sons Herb (left) and Jack as they prepare to work with cattle sometime around 1937. (Courtesy of Beverley Wooten.)

The Burris barn dances were one of the most enjoyed and longest lasting legacies in the Browns Valley–Loma Rica area. These four Burris siblings would supply the music for many years, in addition to playing at Robinson's Corners and other venues. Clockwise from the left are Ray, who played the saxophone and violin; Clyde, trumpet and drums; Alita, piano; and baby Elbert ("Jake") who would play guitar and drums. Their parents were Charles and Ethel Burris. (Courtesy of Ray Hoxworth.)

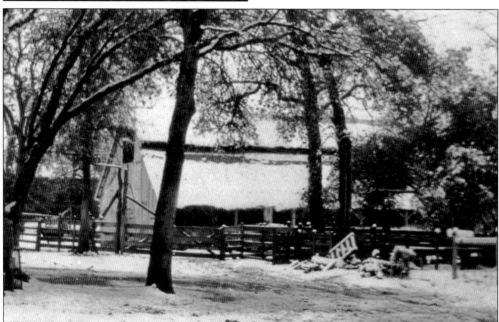

This barn, the site of dances, beginning in 1915, became the place to go on a Saturday night. The barn burned in 1935 and was rebuilt the following year. Dances were suspended from 1941 through 1945 because so many native sons went off to war and all the families' resources were directed to the war effort. Dances were welcomed back in 1946. People were ready to have fun after the grim war. Fights, arguments, and romances started and ended here; a lot happened at the Burris barn dances, where people socialized on Saturday night until it was time to go home and milk the cows. (Courtesy of Ray Hoxworth.)

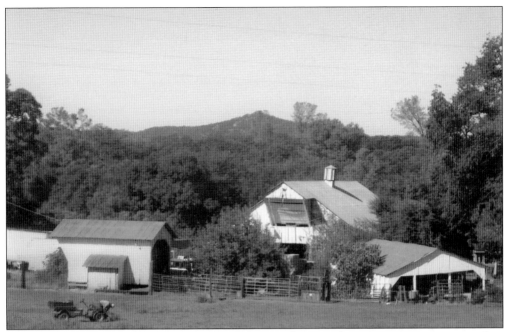

Looking much the same as it did in 1935, the barn is shown today in its reincarnation as a hay and feed store. Dances ended in 1962. (Author's.)

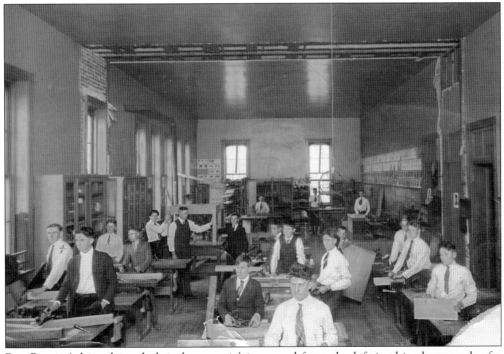

Ray Burris (white shirt, dark jacket, no tie) is second from the left in this photograph of a Marysville High School shop class in 1918. Students dressed up to come to high school. Young men who lived out in the country had done a day's work on the ranch before they got to school. (Courtesy of Ray Hoxworth.)

Charlyn Crawford, Charles Heintzen's great-granddaughter, dressed up for her picture at age four. She started school at Spring Valley, where her five older siblings had attended, but the family of eleven children and parents, Lita and Tom, moved to District Ten shortly after Charlyn entered the first grade. As an adult, Charlyn was a much-respected teacher. She taught for 40 years in the Marysville Joint Unified School District, and 39 of those years were spent at Walter Kynoch Elementary School. (Courtesy of Jean Crawford.)

Six

WORK AND PLAY

Matheson's Flying A gas station stood for years at the south end of Browns Valley at Highway 20. Operated by Howard Matheson and his wife, Grace, it was also home to their grandchildren Norma Jean, Bill, Morry, and Fred Smith. They all attended and graduated from Browns Valley schools. (Courtesy of Morry Smith.)

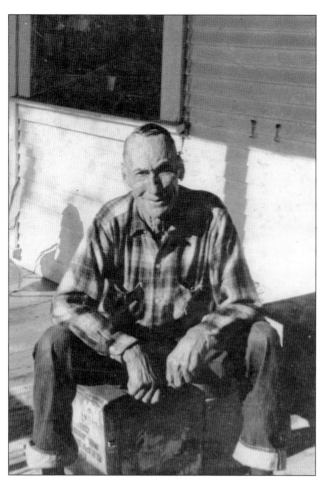

Rupert and Ethel Handy and their 11 children lived on Highway 20 in a sprawling house in a meadow north of the road. They had a dairy and raised hay and beef cattle. Rupert, the patriarch of the family, was always ready with a story or joke. Here, he sits on a peach lug box, the preferred lawn furniture in Browns Valley. (Courtesy of Beverley Rose.)

Rupert is working his fields with a team of horses. (Courtesy of Beverley Rose.)

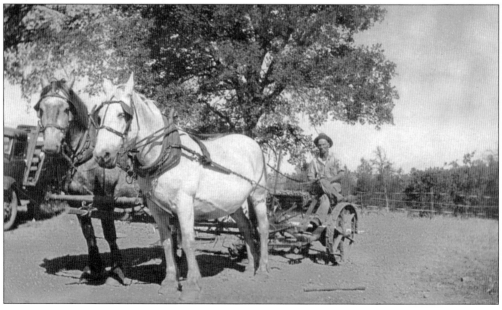

A rare snowy scene highlights the Handy ranch. (Courtesy of Beverly Rose.)

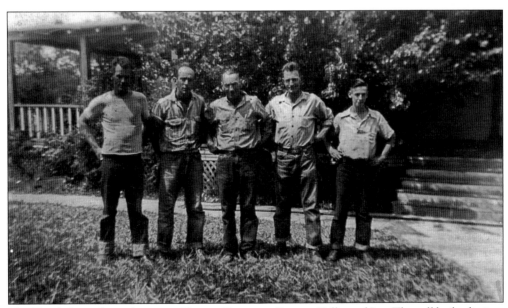

The Handy boys, shown here, are Chester, Pert, papa Rupert, Kelly, and Joe. They all had a distinct hearty laugh that announced their presence. Several sons and sons-in-law served in World War II, and all came home safely. (Courtesy of Beverley Rose.)

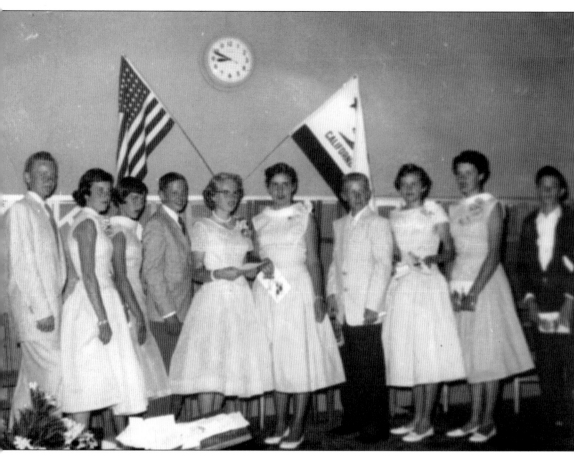

Graduates of the 1957 Foothill School class were, from left to right, Wayne Smith, Susan Yore, Bonnie Barrie, David Labadie, Coralee Jones, Nancy Jones, Dale Hume, Nadine Webster, Marlene Hill, and Fred Smith. (Courtesy of David Labadie.)

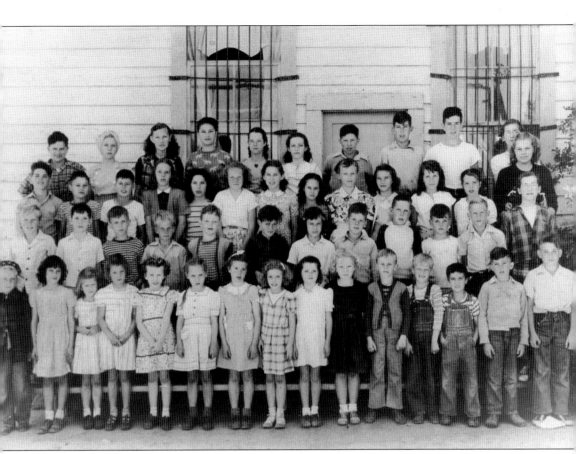

Browns Valley School housed its last class in the old building in 1947. After it closed, it served for several years as a community center, hosting 4-H meetings, Christmas programs, and community gatherings. (Courtesy of Arthur Rice.)

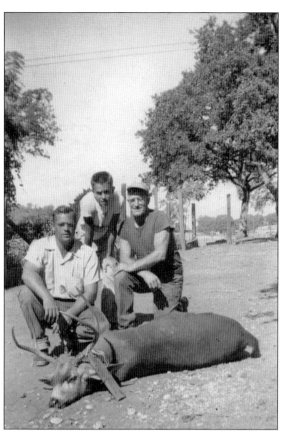

Longtime residents Ray Webster Jr. (center), his father, Bill (right), and his grandfather Raymond Webster Sr. proudly show off a black-tailed buck they shot in the hills above Browns Valley. (Courtesy of Ray Webster.)

The Webster family took a band of sheep to the mountains each summer for many years. The grass was green and lush up there when it was scant and brown in Browns Valley. (Courtesy of Ray Webster.)

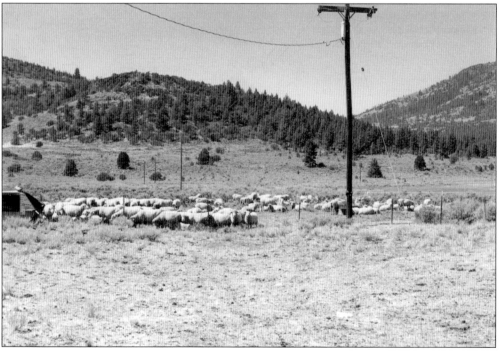

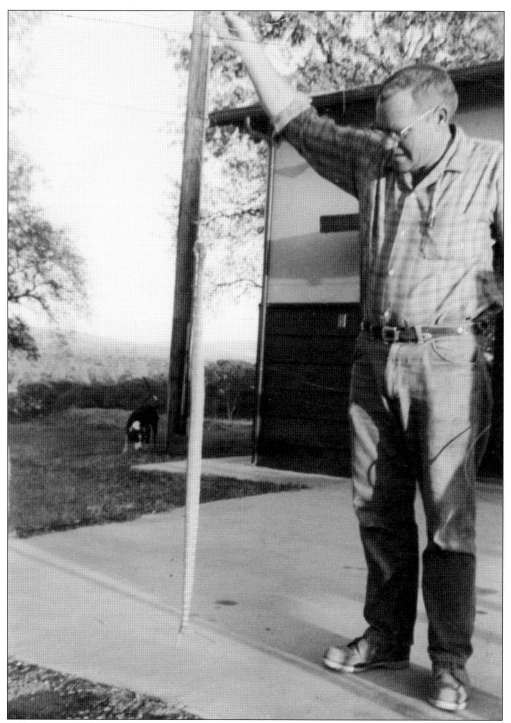

Bill Webster is showing off a large rattlesnake he killed on his patio. Children from the country grow up learning to be cautious and aware of the possibility of rattlers. Bill was always a generous, helpful neighbor to anyone who sought his advice, ready with his tractor and tools. He usually knew the older, better way of accomplishing a task. (Courtesy of Ray Webster.)

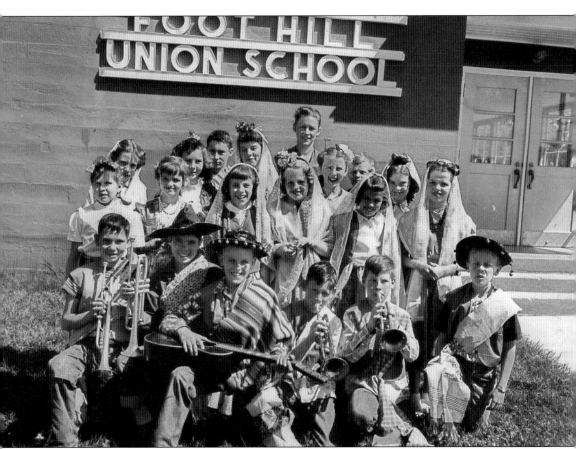

A performance at the new Foothill School was presented to celebrate Mexican culture and music. Pictured are (first row) Dick Coward, Robbie Francis, Mike Yore, Don Springsteen, Arthur Rice, and Allan Bumpas; (second row) Irene Welch, Nadine Webster, Susan Yore, Coralee Jones, Bonnie Barrie, and Anita Coward; (third row) Marlene Hill, Donna Dean, Carolyn Coward, Roberta Sperbeck, and Alice Rice; (fourth row) Dick Hill, Dick Springsteen, and Morry Smith. This school has become Browns Valley School again. (Courtesy of Morry Smith.)

Hazel Burris, the daughter of Byron Burris Sr. and Anna Sersanous, was born in Browns Valley in 1877 and served 15 years as the postmistress at Browns Valley, beginning in 1948. She served many roles in the town, including telephone operator and historian. She was most valuable as a first responder (long before the phrase was invented). People with phones were on 8 or 12 party line, each of which had a distinctive ring. If people had an emergency, such as a fire or accident, they would ring Hazel, she would ring one long ring all along the line, and people knew to pick up and listen and rush to help their neighbor. Hazel would then run out on the porch of the post office and yell up and down the street so patrons in the bar and store would hear the news. Houses were saved from fire and medical aid was obtained in this way long before Browns Valley had a volunteer fire department. (Courtesy of Ivadene Leach.)

Hazel lived her entire 90 years in the house in which she was born, as did her brother Byron Burris Jr. Her mother, Anna, was born in 1860 in the same house and lived all her life there. (Courtesy of Ivadene Leach.)

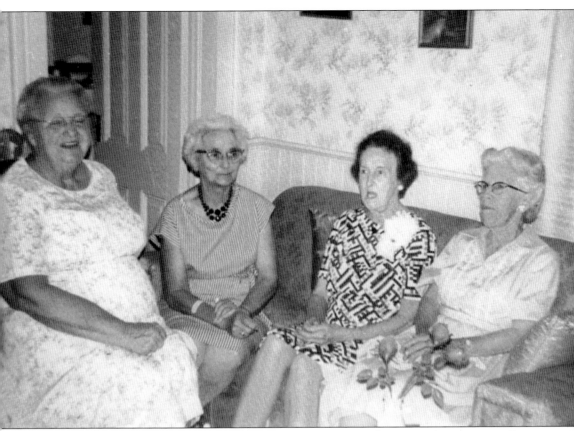

Hazel is shown here at her retirement party, wearing a corsage and enjoying the company of her friends in the old Burris house. From left to right are Lita Heintzen, unidentified, Hazel, and Flora Burns Sperbeck. (Courtesy of Ivadene Leach.)

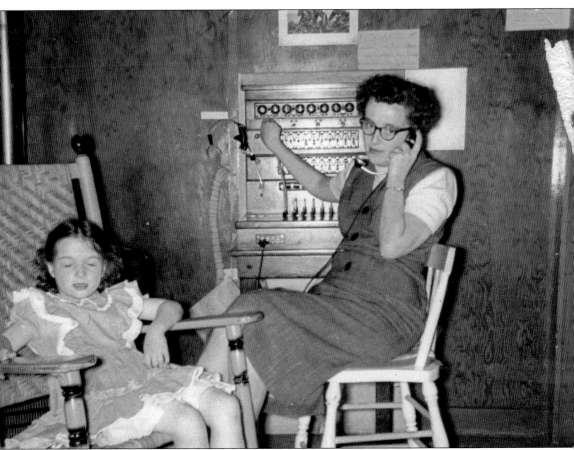

Dorothy Long was the evening phone operator from 4:00 p.m. until 8:00 p.m., after Hazel went home. This switchboard had plug-in lines, which fielded the calls for Browns Valley residents. Until the 1960s, a call to Marysville was long distance and cost extra, so calls were made only when needed. Mary Jane Haskell visited Dorothy frequently in the evenings, as Dorothy operated the switchboard. (Courtesy of Mary McBride.)

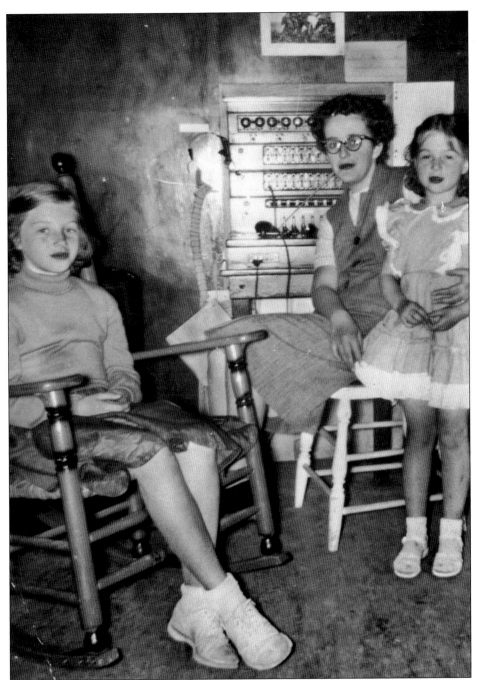

Jeni-Vee (left) and Mary Jane Haskell were the daughters of Fritz and Alta Haskell, a well-respected couple who operated Haskell's Grocery from 1950 to the 1970s. The family lived behind the store. The Haskell sisters are keeping Dorothy Long company as she works her shift. Dating from 1860, this building is the oldest in Browns Valley. The foundation was built from tailings brought from the mines. Before it was covered with stucco, veins of gold could be seen in the south wall. During World War II, Browns Valley women gathered here to sew robes and blankets for the soldiers. (Courtesy of Mary McBride.)

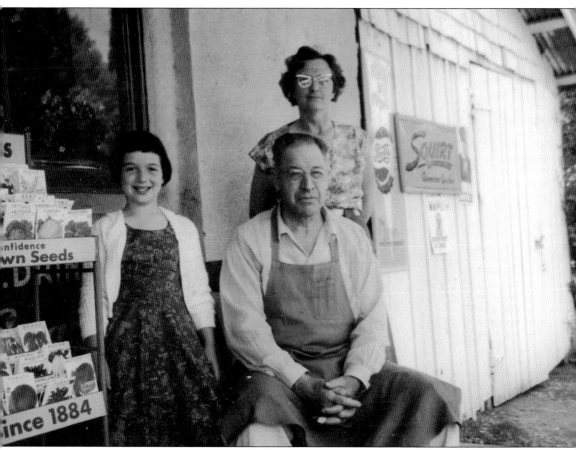

The Haskell family members pause in their workday for a rare photograph. Jeni-Vee (not pictured) is at school. When Fritz and Alta operated Haskell's Grocery, it was a social center for the community. A resident came to the post office to get his mail, discussed news there, then went next door to buy a few items and discuss events of the day with other patrons. (Courtesy of Mary McBride.)

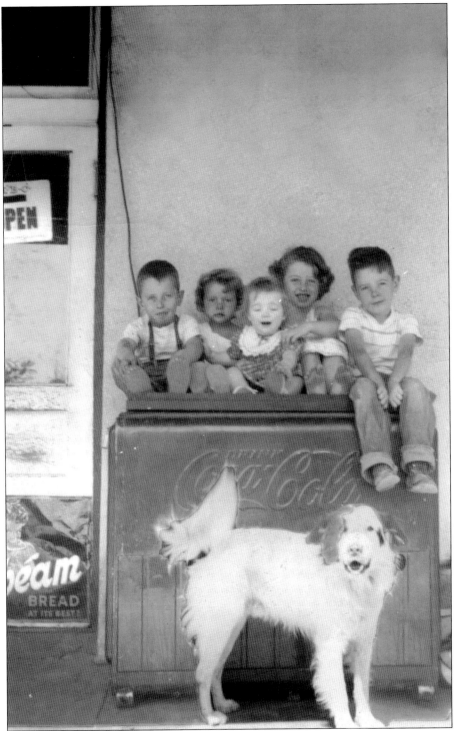

The soda-pop machine at the store was a popular place to sit and chat on a hot day. From left to right, Bob Yore, Beverly Yore, Mary Jane Haskell, Jeni-Vee Haskell, and Charles Yore all wanted to sit on top of it for the picture. (Courtesy of Mary McBride.)

Bob Gee, a well-known cattleman from Browns Valley, is smoking his characteristic cigar. The life of a rancher could be strenuous. Besides buying and selling cattle at the right time each year, a cowman has to mark and brand his cows, castrate the bull calves, medicate and vaccinate them, feed them hay (sometimes all year around), move them from pasture to pasture, spray them for flies, assist with calving, and ensure fences have no holes. Then, they hope the price of beef stays up and no catastrophe happens until they are sold. It is not an easy life. (Courtesy of Myrna Gee.)

Some of Bob Gee's cattle are rounded up to go to market. (Courtesy of Myrna Gee.)

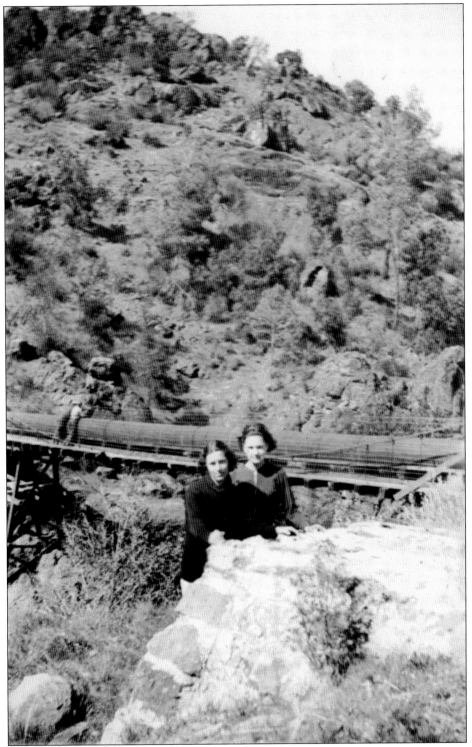

Rosalie Rice, left, and Marie Royat rest after a hike. BVID pipeline is seen in the background. (Courtesy of Arthur Rice.)

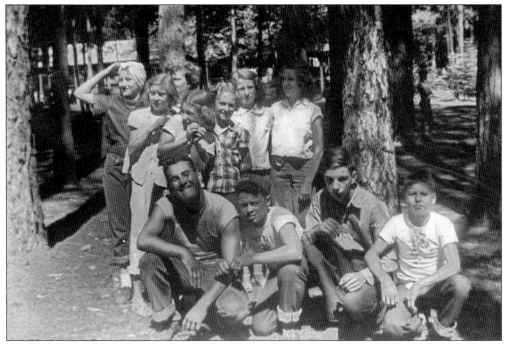

The National 4-H Organization, first started in 1914, became a program of the Cooperative Extension program in 1924. Its motto, "to make the best better," reflected the goals of engaging rural youth in their communities, building self-reliant and independent young people, and encouraging the acquirement of new skills and the implementation of new ideas, particularly in agriculture. Browns Valley and Loma Rica had large, thriving clubs since their beginnings in 1928. Club members worked on projects—such as sewing; photography; raising calves, pigs, rabbits, and chickens; cooking; woodworking; and many other skills. These Browns Valley members pose at 4-H Camp. (Courtesy of Charles French.)

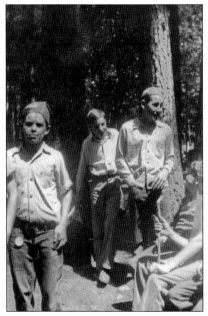

Ray Hoxworth, Joe Rice, and Clarence Binninger enjoy 4-H Camp. After 4-H projects and participation in the county fair were completed, the reward for all club members was attending 4-H Camp. All clubs in Yuba County attended the same camp at Dobbins. (Courtesy of Charles French.)

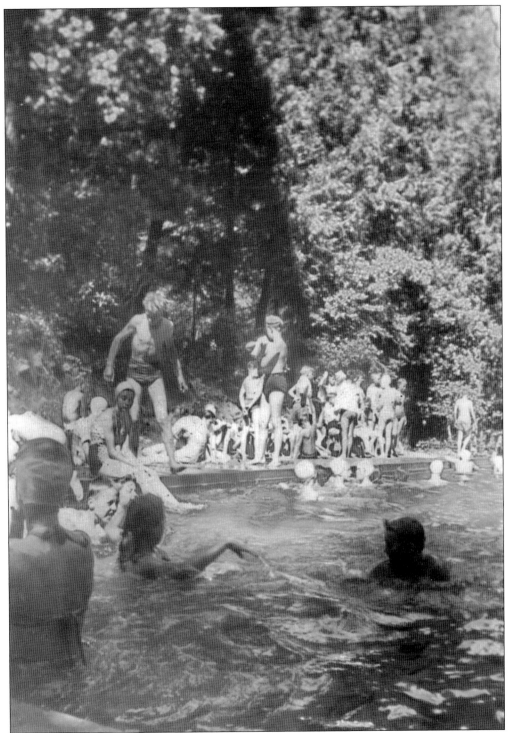

The 4-H Camp pool was known to have the coldest swimming water in Yuba County. Here, brave club members take a quick dip. In the evening at camp, there was a campfire, singing, and entertainment by different clubs. (Courtesy of Charles French.)

The Farm Bureau, established in March 1918 in Yuba County, aimed to advance agriculture in the county and to disseminate credible information to farmers and ranchers. Twenty percent of the farmers had to join the Farm Bureau before a farm advisor could be appointed. "If a farmer does not demand a square deal, no one else will do it for him" were the stirring words printed in *The Monterey County Farm Bureau Monthly* in 1919 to spur farmers to join. (Courtesy of Yuba Sutter Farm Bureau.)

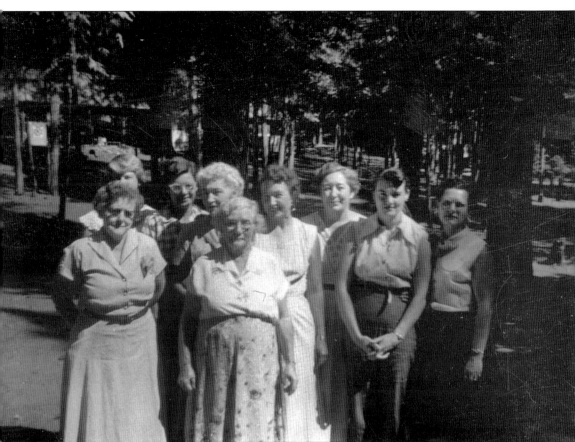

The Yuba County Home Department, a program of the Farm Bureau, provided social support and information on new technology and products to women in rural communities. For many years, Tunia Vandebout (the representative for Browns Valley, Loma Rica, and other small towns) brought programs on such subjects as "How to Choose a Mattress" or "New Ideas in Canning" to groups that met in members' homes. The real value of the get-togethers were the long-term friendships that formed around the coffee pot. In addition to meetings, volunteer work, and projects, the Home Department provided a day camp in the summer for the women at the 4-H Camp. These events were a welcome break for hardworking women. Ethel Handy (far left, front), Ruby Gee (third from right), Betty Pickett Kunde (second from right), Lena Bordsen (far right), and four unidentified women are enjoying the shady coolness. (Courtesy of Betty Kunde.)

The new Foothill School was built across the road from the old school in 1948. The large playground and the indoor bathrooms were much appreciated by the students. (Courtesy of Arthur Rice.)

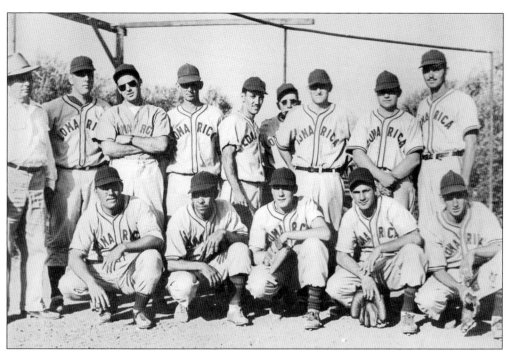

From the 1920s to the 1950s, many of the small, country towns in Yuba County had baseball teams. These were not casual pickup games but were formalized with uniforms and rosters and heated with intense rivalries. Here are the Loma Rica Olives of 1949. Pictured are, from left to right, (first row) D. Hughes, Elmer Potts, Jerry Rose, Bob Day, and Joe Handy; (second row) Elmer Kroesen, Pat Sperbeck, Bob McCee, Merle Russell, Leo Rose, manager Joe Rose, two unidentified, and Louie Newton. (Courtesy of Jerry Rose.)

A 1947 clipping illustrates part of the process of joining a team. The Loma Rica field today is covered with olive trees just north of Foothill School on Fruitland Road. The hottest rivalry was between the Olives and the Browns Valley Cubs, whose home field was on the school grounds at Browns Valley. (Author's.)

CALL IS ISSUED

Lloyd Sperbeck is the first Foothill league baseball manager to call his team out for practice this year. Sperbeck has issued a call for all players who desire to try out for the Browns Valley Cubs this year to assemble next Sunday on the Browns Valley grounds and a light workout will be held.

The practice will be merely to work out the kinks which settle in an active ball player during the winter. Sperbeck will start the practice at 2:30 p. m. and hopes to get in a good workout if Jup Pluvius is friendly. Suits will be given out by the Browns Valley manager when he has picked his squad.

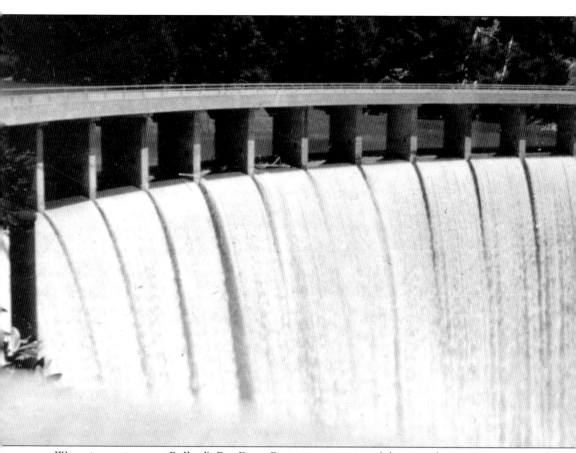

Water is pouring over Bullard's Bar Dam. Boating, swimming, fishing, and camping are enjoyed by all foothill residents at this multiuse dam. It also provides vital flood control to the lower part of the county. (Courtesy of Arthur Rice.)

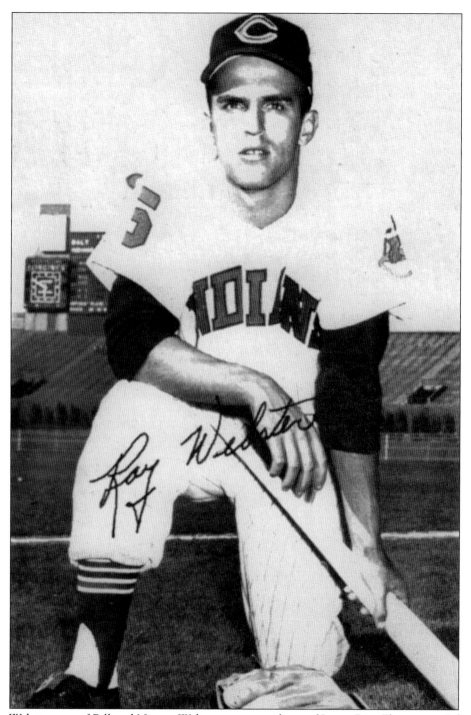

Ray Webster, son of Bill and Norma Webster, was a graduate of Loma Rica Elementary School and a longtime Browns Valley resident. He played for the Sacramento Solons in the Pacific Coast League after graduating from high school and was then was drafted by the Cleveland Indians. He played 40 games for Cleveland in 1959 and 7 games for Boston in 1960. He spent nine years in the major leagues. (Courtesy of Ray Webster.)

The Milwaukee Braves drafted Harold "Hap" Ritchie, grandson of Rupert and Ethel Handy, in 1958. He moved up the ranks, eventually playing two seasons of Triple A ball. He played for the Washington Senators' and New York Yankees' organizations and played in Toronto in the International League. (Courtesy of Beverley Rose.)

A

True Story

OF

𝕭𝖗𝖔𝖜𝖓𝖘

𝖁𝖆𝖑𝖑𝖊𝖞

ITS

Past

Present

AND *Future*

Compiled by the Browns
Valley Farm Center

This little booklet published in 1930 details the advantages of living in such a wonderful place as Browns Valley and predicts a rosy future for its citizens. (Courtesy of Jean Crawford.)

DISCOVER THOUSANDS OF LOCAL HISTORY BOOKS FEATURING MILLIONS OF VINTAGE IMAGES

Arcadia Publishing, the leading local history publisher in the United States, is committed to making history accessible and meaningful through publishing books that celebrate and preserve the heritage of America's people and places.

Find more books like this at
www.arcadiapublishing.com

Search for your hometown history, your old stomping grounds, and even your favorite sports team.